Surrealism

Surrealism

PATRICK WALDBERG

McGraw-Hill Book Company
New York · Toronto

To Marie-Laure

Contents

759.06
W15S

1-19-84
Stains at
top of pages
+ ink underlining

Preface

It has been said that there is no surrealist art, and this is true. Surrealism, originally elaborated by poets, can be defined not as a matter of aesthetics but as a way of knowing and a kind of ethics. 'To change life,' according to Rimbaud, was the prime concern.

However, a number of artists who were in agreement with the poets associated themselves with the surrealist movement and endeavoured to put its various methods of expression into practice. Recourse to the imaginary, to dreams, to the unconscious and to chance stimulated and inspired a number of important painters, those at the heart of the movement as well as those outside it, to such an extent that it is not incorrect today to speak of surrealist painting or art, always bearing in mind that it is not a question of a school or a formal movement, but of a spiritual orientation.

In fact, when the works of various surrealists are assembled, what is striking is not their 'family resemblance', as in the case of the cubists, the fauves, or the *tachistes;* it is above all their difference.

It is difficult to demarcate surrealism in art. But we can, broadly speaking, discern two great tendencies, which are quite dissimilar with regard to their plastic results. There is on the one hand the class of painters for whom calligraphy, animation and movement are the essentials, regardless of the subject represented. Max Ernst, André Masson, Miró, Matta, Jacques Hérold and Wifredo Lam belong to this category. On the other hand, there are the 'descriptives', who were inspired by Chirico. Among them we find René Magritte, Salvador Dali, Paul Delvaux, Toyen and others. With the former, the idea is simply suggested without concern for exact representation; with the latter, the scene is unreal, but the setting, the objects, and the human figures which comprise it are painted with fidelity. For the sake of convenience, we could designate the first group by the name of emblematics, while the second would be the naturalists of the imaginary.

These distinctions are obviously not absolute. Certain artists waver between the two poles, either by resorting to archetypes, to the traditional signs of magic (Victor Brauner, Kurt Seligman), or by seeking an ambiguous fantasy, in which the definiteness of the subject alternates with a deliberate vagueness (Léonor Fini, Marie-Laure). Others, finally, have passed from a scrupulous realism to a fusion in space in which the significant forms are no more than indicated (Dorothea Tanning).

Automatism, or the 'dictation of thought without control of the mind', implies the intervention of chance and the abandonment of the critical mind. We know that surrealism placed the greatest hopes on automatic techniques of expression. These processes are of various types. The simplest of them is rapid drawing – executed, so to speak, with the eyes closed – in which the personality of the artist is expressed directly, from the subconscious, a method that demands an unusual state of tension, and one in which André Masson excelled. Other processes are of a mechanical nature, such as collages, which allowed Max Ernst to elaborate works of incomparable diversity and depth, or decalcomania, first applied by Oscar Dominguez and later perfected by Max Ernst. It should be noted, however, that the surrealists never considered such automatic processes as ends in themselves. If they resorted systematically to the dictates of the unconscious, to the products of chance, and if these interventions outside the will were judged by them as essential, they still did not consider them sufficient. The unconscious, chance, served them as springboards, furnishing the initial impulse, the direction, the harmonic curve of the work; but, with rare exceptions, the artist used those as raw materials in the task of interpretation and ordering which gives the finished work its profound meaning.

There is among all the surrealist artists a desire to find, over and beyond appearances, a truer reality, a kind of synthesis of the exterior world and of the interior model. The awareness of this 'surreality' is caused most frequently by the sense of bewilderment. With the emblematics as well as with the naturalists, human figures and objects are divorced from their natural function and placed opposite one another in a relationship which is unexpected – perhaps shocking – and which therefore gives each of them a new presence.

Finally, the surrealist poets and artists devoted themselves, on the plastic level, to experiments, to investigations, even to games, in the majority of which art was secondary. As early as 1913 Marcel Duchamp, that great precursor, was able to take any object whatsoever and raise it to the level of a work of art by changing its name and calling it 'ready-made'. Francis Picabia, on the other hand, introduced manufactured elements (toothpicks, matches, etc.) into his

paintings. After 1920 Max Ernst, Jean Arp and Kurt Schwitters used collages or constructions of printed paper, fragments of wood, trinkets and scraps of every kind. André Masson mixed unusual materials – such as sand or seashells – with his automatic calligraphy. Joan Miró nailed a real door or braids of string to a painting, or glued strands of hair to it. Lastly, the object 'with a symbolic function', which Salvador Dali originated, gave rise to an abundance of personal or collective works in which all the surrealists took part.

These experiments – or rather these adventures – were born in a climate of effervescence, of collective exaltation in which poetry and art were no longer differentiated. It is to this that most surrealist works owe their unique character. It is also for this reason that we cannot approach them on the level of art criticism alone; any commentary on them requires a consideration of the spiritual sources as well as of the ethical and poetic intentions.

The Paths of Surrealism

The Word

The word 'surrealist' first appeared in the year 1917. In that year Guillaume Apollinaire produced a burlesque play, *Les Mamelles de Tirésias,* which he described as a 'surrealist drama'. But it never entered the mind of the poet of *Alcools* to define a doctrine, and even less to found a school. Nevertheless, the word he had coined caught on. It quickly became fashionable in those literary and artistic circles where Apollinaire was idolized. Paul Dermée took it up, in its adjectival form, in the first issue of the review *L'Esprit Nouveau* in 1920. Yvan Goll during his entire lifetime never stopped asserting that he had been the first to give the word its substantive value *(Surréalisme,* October, 1924, single issue), thereby setting himself up as the true inventor of surrealism.

In fact, these questions of origin and of priority are somewhat beside the point, and there is every reason to believe that surrealism would have remained a 'precious' or erudite term (like 'Gongorism' or 'euphuism', for instance) if André Breton had not at one stroke, in 1924, infused it with all the obscure power of dreams, of the unconscious and of rebellion.

The *Manifeste du Surréalisme* (1924), a fervent and haughty little book, gave the following definition of the word:

SURREALISM, noun, masc., pure psychic automatism by which it is intended to express, either verbally or in writing, the true function of thought. Thought dictated in the absence of all control exerted by reason, and outside all aesthetic or moral preoccupations.

ENCYCL. *Philos.* Surrealism is based on the belief in the superior reality of certain forms of association heretofore neglected, in the omnipotence of the dream, and in the disinterested play of thought. It leads to the permanent destruction of all other psychic mechanisms and to its substitution for them in the solution of the principal problems of life.

It is evident that such a definition, no matter how precise and categorical it is, cannot be detached from its context, in which André Breton, in inspired language, describes the new orientation.

Before studying this important document in detail, it should be mentioned that the term 'surrealism' can be interpreted in quite different ways, depending on whether it is taken in the orthodox sense which was championed by Breton and his circle, or in the extremely diluted sense in which it is currently used by some critics and by the public. In the latter case, it can be replaced without harm by such expressions as 'fantastic', 'bizarre', 'unusual', or even 'mad'. It goes without saying that such a popular notion, without being false – for all these epithets can be applied to surrealist works – is nonetheless insufficient.

Strangely enough, it can be pointed out that the word 'surrealist' was recorded in the official journal of the French Republic for the first time in 1934, in the report of a speech given by Albert Sarraut, President of the Council, to the Chamber of Deputies. In reply to two particularly aggressive interpellators, Sarraut declared that he refused 'to be led to the torture, *as in a surrealistic painting by Salvador Dali,* between the hatchet of Monsieur Frossard and the razor of Monsieur Bergery'.

Always exceedingly prudent in its evaluation of neologisms, the *Nouveau Petit Larousse Illustré* waited until its edition of 1949 to give the following description of surrealism: 'The tendency of a school (originated about 1924) to neglect all logical preoccupation.' But in the historical section of the same work, these details were given: 'Based on the works of Rimbaud, Lautréamont, and G. Apollinaire, the literary movement which, in 1924, took the name of surrealism had as its principal exponents A. Breton, L. Aragon and P. Eluard. Its aim is to express pure thought, freed of all controls imposed by reason and by moral and social prejudices.' Succinct as these lines may be, one cannot minimize their importance, for the introduction of the word 'surrealism' in a book so widely distributed was a response to its current usage.

It is the purpose of this introduction to describe the intentions and the goals of those who were the initiators and protagonists of surrealism. I shall indicate the progressions and the offshoots of the 'movement', while recording its considerable contributions and influence in the realm of plastic expression. But it should not be forgotten that although it is in painting, sculpture, and the object that the surrealist idea found its most striking application, surrealism at its inception was intended to be a way of thinking, a way of feeling and a way of life.

I. André Masson, *Gradiva,* 1939

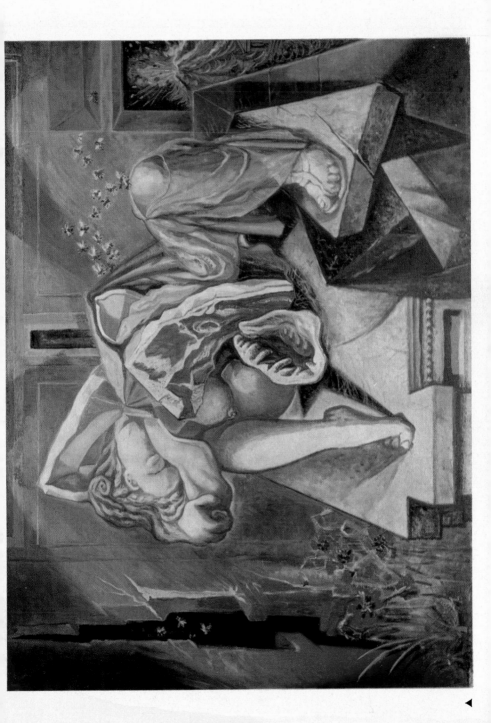

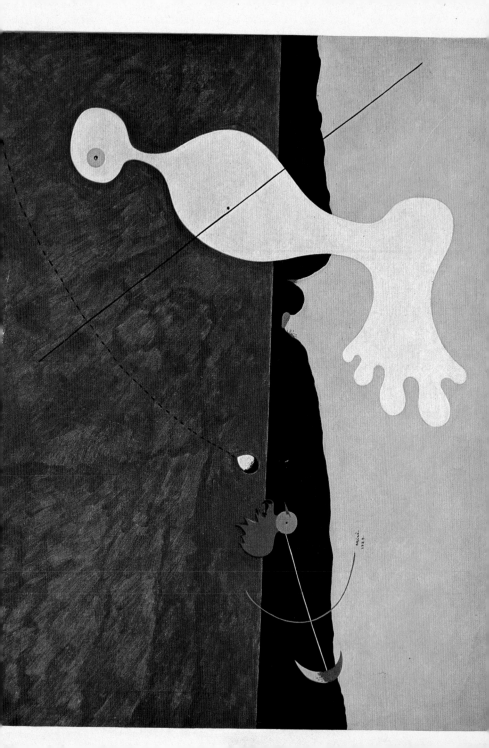

Thus surrealism was born in Paris, with poets as its sponsors. It was among young poets, in fact – those who directed the review *Littérature* between 1919 and 1924 – that the state of mind was crystallized which was to result in the publication of the Manifesto and in the creation of the movement.

From the past they claimed Rimbaud, Lautréamont and Mallarmé, and from among their contemporaries, Apollinaire and Pierre Reverdy. Other influences – Gérard de Nerval, the German Romantics, and the English 'Gothic' novel – were equally discernible.

Directed at the start by Louis Aragon, André Breton and Philippe Soupault (whose ages ranged from twenty-three to twenty-five), the review *Littérature* was tolerant at first. In the first summaries one found the names of most of the frequenters of Adrienne Monnier's House of the Friends of Books: Paul Valéry, André Gide, Léon-Paul Fargue, Valery Larbaud, Jules Romains, all traditional writers, side by side with the representatives of an *avant-garde* closer to Apollinaire and to Picasso – Blaise Cendrars and Max Jacob – or even to Jean Cocteau, Georges Auric and Darius Milhaud. But the youthful triumvirate were soon to lose patience over what they called the spiritual carelessness of their elders. The arrival in Paris of Tristan Tzara, who had been one of the originators of the Dada movement in Zürich, hastened the *Littérature* group on the road towards rebellion and scandal.

It is not necessary here to recall all the different adventures that characterized the Dada movement in Paris, with its succession of 'manifestations', festivals, receptions, and both public and private provocations. Let us say simply that the poets of *Littérature* took part in them primarily for reasons of nonconformity and out of distaste for the inertia of the bourgeoisie, whom even the atrocities of war – the memory of which was still burning – had not succeeded in arousing. André Breton and his friends were not deniers, like the systematic Dadaists. Through all those vociferations, refusals and deliberate absurdities, they were seeking a guiding light, a way to make a new truth dawn.

A distrust of rationalism and formal conventions (which were worshipped at that time by the representatives of the *avant-garde)* prompted the young men towards the exploration of the realm of the unconscious and the dream. They were seeking what might be called 'the language of the soul', that is, the expression – stripped of all logical device – of the profound 'me' in its nakedness. In this way the process called 'automatic writing' came into being, which resul-

ted in the first authentically 'surrealist' work: *The Magnetic Fields* (1922) by André Breton and Philippe Soupault.

Already this work, written 'at the dictation of the unconscious' – thus making it impossible to distinguish which parts were written by which author – gave proof of their indifference to the individual work ornamented by a single signature. Collective experiences multiplied. During the so-called 'dream' period – in which Robert Desnos, René Crevel, and Benjamin Péret were particularly successful – the 'subject' went into a trance and, like the Sybils of antiquity, uttered obscure words. His friends then proceeded to question him and the strange dialogue that ensued was considered a model of true poetry, superior to all poetic forms then in use. A description of such 'seances' can be found in 'Entrance of the Mediums' *(Litt.* No. 6).

Ever since 1920, *Littérature,* under Tristan Tzara's influence, had given a preponderant place to Dada, in particular publishing a special issue (No. 13), 'Twenty-three Manifestos of the Dada Movement'. But, as I have already indicated, there was a fundamental incompatibility between the perpetual exhibitionism and the purely destructive spirit of Dada on the one hand, and the poetic faith that inspired the future surrealists on the other.

In March of 1922 André Breton decided to assume sole direction of the new series of *Littérature,* which led to a final break with the literary *avant-garde* as well as with Dada. For a better understanding of surrealism, a consultation of this new series is fruitful. One finds in the first issue a cover by Man Ray, who had just arrived from New York. In the second issue, Breton repudiates Tristan Tzara and Dada, at the same time opening the door to Francis Picabia *(Litt.* n. s. No. 2, 'Let Go of Everything'). Picabia was to design the covers of all the following issues, just as he was to 'tell' his thought in the form of witticisms, aphorisms and snap-judgments. Shortly afterward, Breton discovered Marcel Duchamp *(Litt.* n. s. No. 5). Max Ernst, after having exhibited his collages at the gallery Au Sans Pareil in May and June of 1920, was visited in Cologne by Paul Eluard, who persuaded him to come to Paris. He settled there in August 1922 and from that time on he collaborated in the production of *Littérature* (n. s. Nos. 7, 8, 9, 11, 12).

Thus the team was already more or less assembled which, under the leadership of Breton, was to form the first nucleus of the surrealist movement.

Littérature, whose title had been chosen out of derision for the subject designated, became with the new series the organ of the surrealists' 'anti-literary' spirit. The review published essays, fiction or analytical criticism. Poetry took precedence, where the poets were also 'seers'. Especially welcome were accounts

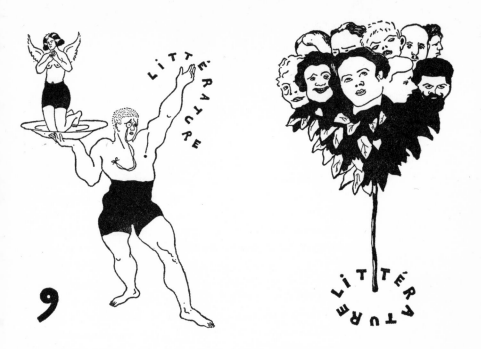

Cover drawings for *Littérature* by Francis Picabia ('Athlete with monocle', February 1923; 'Tree with head blossoms', January 1923).

of dreams, 'surrealist texts', 'automatic writing', 'investigations' concerning the tastes and preference of everyone. Eventually the group came to meet regularly at Paul Eluard's place in Saint-Brice, in the forest of Saint-Leu, or in Paris at the home of Breton or some other member. From time to time the new friends set off together in search of places full of magic, inviting the intervention of 'accidents', or significant incidents. In June of 1924 the 'movement', apart from the original triumvirate of *Littérature,* included Paul Eluard, Benjamin Péret, Robert Desnos, Roger Vitrac, Max Morise, Georges Limbour, Joseph Delteil, Jacques Baron, René Crevel and the painters Francis Picabia, Man Ray, Marcel Duchamp and Max Ernst.

In 1924 André Breton's *Manifeste du Surréalisme* appeared. In it were condensed the aspirations and the doubts, but especially the hopes, of a large number of young men: first, of the 'group' of *Littérature*, for whom the book expressed what was already a daily reality; then, of those who came to enlist in the 'movement' and to enrich the ranks of *La Révolution Surréaliste;* lastly, the sympathetic, interested, dubious and ambivalent, who formed the first audience of this new *Weltanschauung.*

Imagination, folly, dream, surrender to the dark forces of the unconscious and recourse to the marvellous are here opposed, and preferred, to all that arises from necessity, from a logical order, from the reasonable. 'Dear imagination', wrote Breton, 'what I especially like about you is that you do not forgive.' And: 'Only imagination makes me aware of the possible, and that is enough to lift a little the terrible restriction; enough also for me to surrender to imagination without fear of being mistaken (as if one could be more mistaken).' Folly, or at least what reasonable men designate by this word, is considered by Breton to be a manner of understanding reality which is as valid as that of ordinary men, if not more so. 'Hallucinations, illusions', he said, 'are not a negligible source of pleasure . . . The confidences of madmen: I would spend my life in provoking them. They are people of a scrupulous honesty, and whose innocence is equalled only by mine. Columbus had to sail with madmen to discover America. And see how that folly has taken form and endured.'

The dream – and recognition of the omnipotence of the dream – will comprise one of the strongholds of the surrealist position. And homage will be paid to Freud, who was the first to lift the veil of consciousness and to systematize the analysis of dreams as a means of knowing man. The Freudian dynamic will become an article of faith for the surrealists. 'From the moment when . . . we will succeed in realizing the dream in its integrity . . . when its contour will develop with unequalled regularity and breadth, we can hope that mysteries – which are not really mysteries – will yield to the great Mystery. I believe in the future resolution of those two states, so contradictory in appearance – dream and reality – into a kind of absolute reality, of *surreality,* if one may call it so.'

In the first section gave the encyclopaedic definition of surrealism as it appeared in the Manifesto. The notion of 'surreality', conceived as an ideal goal-but not inaccessible – brings a considerable enlargement to this definition. In fact, it is no longer a question of a manner of expression, of a style of writing

or painting, but of a general orientation of the spirit, directed completely towards the conquest of an 'elsewhere'.

The originality of surrealism – as it is affirmed in the Manifesto – and that which distinguishes it from all the literary and artistic movements which preceded it (with the possible exception of some phases of German romanticism) is its determination to minimize the fragmentation of consciousness and to arrive at a totality of the human being.

The 'prosecution of the real world' – the phrase is Breton's – implies on the one hand a prizing of the virtues of the unconscious and the dream, and on the other hand the search for a state of grace which belongs to childhood: 'If [man] retains some lucidity', wrote Breton, 'he cannot help turning back towards his childhood which, spoiled though it was by his trainers, seems to him no less full of charms. There the absence of all known severity leaves him the perspective of several lives led at the same time . . . Every morning children leave without anxiety. All is ready, the worst material conditions are excellent. The woods are white or black, they will never go to sleep.'

According to these various ideas, surrealism proclaims irresponsibility, asserting that man must escape from the control of reason as well as from the imperatives of a moral order. Thus, while declaring himself a nonconformist, he brings his essential prejudices to bear on those states of surrender among the first of which is found the dream and, along with it, that state of vision advocated by Rimbaud ('One must be a seer, make oneself a seer'). There is, too, the state of the medium, whose hand is no more than the instrument for transmitting a message, sent not from the spiritualist hereafter, but from the actual self hidden by consciousness.

Finally, in its dual and indomitable opposition to the spiritualism of the Christian Church as well as to Cartesianism (which, according to its theory, paralyses occidental thought), surrealism rehabilitates superstition and magic at the same time that it turns towards the Hermetic tradition (Cabala, Gnosticism, Alchemy) which rests on the exercise of analogical thought.

The Surrealist Revolution

Judging by the contents of Breton's Manifesto alone, one might see in surrealism only a shoot of the Romantic tree, on which would be grafted amazing branches of symbolism and which would be made stranger still by a cutting

from Freudian theory. We can in fact find in Novalis, Arnim and Nerval, in Lautréamont, Rimbaud and Mallarmé, most of the assertions which comprise the text of the Manifesto. The difference is that the intuitions and accounts of individual experience that we find in these poets have been brought together by Breton into a body of doctrine which is a kind of Declaration of the Rights (and Duties) of the Poet. For Breton, this collection of points of view will serve as the springboard for a collective venture.

We must insist on the fact – too often passed over in silence by critics when they are dealing with a work of surrealist character, and mostly unknown to the general public – that surrealism was from start to finish a revolutionary movement. The surrealists had two passwords: 'To change life' (Rimbaud) and 'To transform the world' (Marx). To change life meant to modify feeling, to guide the spirit in new directions, to wean the individual away from a rational view of the world. To this poetic requirement was added that of transforming the world on the social and moral level. Surrealist politics, tainted at its beginning by anarchism, did not take long to channel itself towards the parties of the extreme Left claiming ties with Marxism. *La Révolution Surréaliste* was the organ of the movement between 1924 and 1929; and one can discern in it a rapid evolution from the near-nihilism of its beginnings to its adherence to the Communist Party line (late 1929 – early 1930), which was marked by the circulation of a new review, *Le Surréalisme au Service de la Révolution* (1929–1933).

One can say with complete objectivity that the surrealists were quite ineffectual in their various political stands. It was paradoxical, in fact, to attempt to make Marxism, founded on reason, compatible with the surrealist priority given to dreams and to irrational modes of knowledge. And, anyway, the workers' movements mistrusted the poets, who were all of bourgeois origin and whose zeal and verbal excesses exasperated them.

Politics was one of the principal sources of discord in the surrealist movement, the entire history of which was marked by conflicts, self-contradictions, denunciations and exclusions. Breton, when he put himself at the service of the Communist Party, brought along very few of his followers, but Louis Aragon did join the Party, to be followed in 1939 by Paul Eluard. But Breton himself was not long able to stand what he considered the totalitarian discipline and reactionary spirit (as to thought and its expression) that characterized the cell meetings of the Party. The surrealist movement therefore went over to what has been called 'opposition from the left', or in other words, Trotskyism. Encouraged by his personal meeting with Leon Trotsky in Mexico in 1938, Breton's 'oppositional' feelings were given practical expression by the foundation, in association with Diego

Nº 5 — Première année 15 Octobre 1925

LA RÉVOLUTION SURRÉALISTE

LE PASSÉ

ADMINISTRATION : 42, Rue Fontaine, PARIS (IXᵉ)

ABONNEMENT,
les 12 Numéros :
France : 45 francs
Étranger : 55 francs

Dépositaire général : Librairie GALLIMARD
15, Boulevard Raspail, 15
PARIS (VIIᵉ)

LE NUMÉRO :
France : 4 francs
Étranger : 5 francs

Title page of La Révolution Surréaliste, No. 5, 1925.

Rivera, of the FIARI (International Federation of Independent Revolutionary Artists).

Since that period, brutally disrupted by the Second World War, the political alignment of the official 'group' led by Breton has had various fluctuations, including a reconciliation with the anarchists and the resumption of the motto: 'Open the prisons, disband the army!' (1946–1948); adherence to the ephemeral pacifist movement of the rather naive Garry Davis (1949); a stand against the war in Algeria and against Gaullism (1958–1962); and so on. But after the liberation the attention that the public gave to these surrealist manifestations diminished considerably.

If it is true that between 1924 and 1936 surrealist agitation had the power to influence some of the young intellectuals, today the group's influence – at least as a group – has practically ceased to exist. The earlier writings of Breton, Aragon and Eluard have, without question, become classics in the academic sense of the word. But it is mainly in France that they are still read; foreigners consider them more as interesting curiosities or as useful references.

The surrealist idea took shape in the world through the influence of the painters. Max Ernst, Miró, Masson, Tanguy, Magritte and Dali were the purveyors of surrealism to the world at large, while the audience of the theoreticians, poets and writers was almost completely restricted to their own country – and, indeed, to a minority in that country.

The Taste of the Poets

Between 1905 and 1917, a period of great upheavals and revolutions in the world – particularly in the plastic arts – the public attended with astonishment, even met with revolt, the exhibitions that presented the new forms which baffled the eye and confused the mind. With rare discernment Guillaume Apollinaire was the first effective and sympathetic champion of this 'modernity'. Not only did he professionally defend this art of 'upsetting', but he befriended the painters and profited by his contact with them just as the latter gained much from him.

Apollinaire's first article of art criticism was devoted to Picasso *(La Plume,* 1905). In 1907 he praised Matisse in *La Phalange.* In 1908, after having honoured Henri Rousseau at a banquet in Picasso's studio, he wrote a preface for an exhibition by Georges Braque. That same year André Derain illustrated his first published work, *The Rotting Enchanter.* In 1912, it was Raoul Dufy

III. Salvador Dali, *The Dismal Sport,* 1932

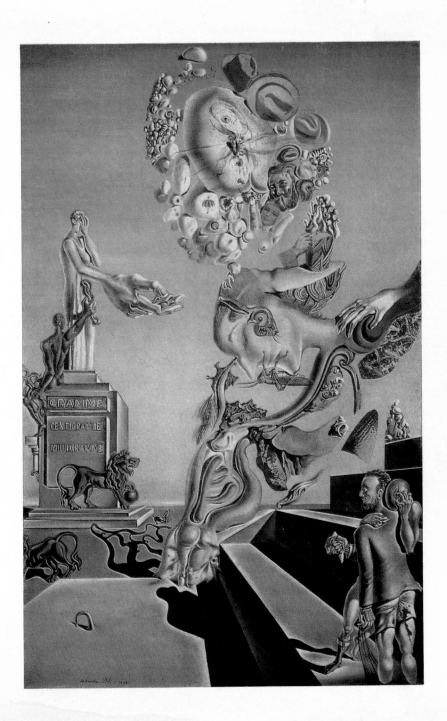

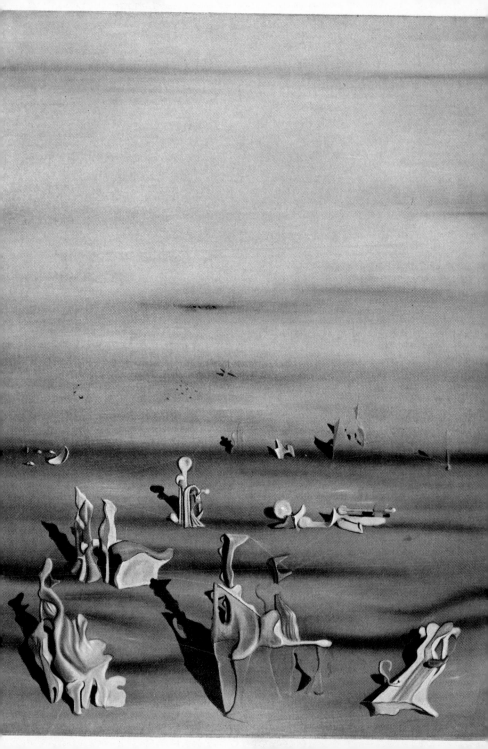

who prepared the illustrations for the first collection of Apollinaire's poems, *The Bestiary*. In 1912 the 'enchanter' pursued his crusade in favour of the new painting in *The Evenings of Paris* and *The Little Blue* (in which he defended the futurists). In 1912, at Gabrielle Buffet's house in Estival, he gave a reading of the splendid poem *Eau-de-vie* before two young painters who were to play a very important role in the development of the surrealist spirit: Francis Picabia and Marcel Duchamp. *Eau-de-vie* changed its title and became *Zone*, the poem which opened the collection *Alcools* (Paris, 1913). Towards the end of 1912 he composed *The Windows*, based on a painting by Robert Delaunay. Early in 1913 Apollinaire and Delaunay, en route for Berlin, visited Cologne at the invitation of August Macke, a friend of Klee's and a member of the famous *Blaue Reiter* group. At Macke's home a silent young man listened avidly to the poet's words: it was Max Ernst, and he did not forget the meeting. To Marc Chagall, who had been in Paris since 1910, Apollinaire dedicated one of his most unusual poems, *Across Europe,* while for Giorgio de Chirico he was to invent several of the titles which adorn the work of the painter of the Enigmas. When we consider that all these painters, universally renowned today, were among the most controversial during Apollinaire's lifetime, we cannot fail to be struck by the poet's foresight. And I have not yet listed some of the other distinguished names who were among the poet's friends: Juan Gris, Fernand Léger, Roger de la Fresnaye, Serge Ferat, Albert Gleizes, Jean Metzinger, Gino Severini and Umberto Boccioni.

Between 1916 and 1918, during the last two years of the poet's life, we can say that the spirit of André Breton was in complete accord with that of Apollinaire. It is no exaggeration to say that the latter was, in art, the initiator *par exellence.* His influence, then, on the formation of Breton's taste and critical spirit – and, consequently, on the surrealist aesthetic – was undoubtedly considerable. So we are justified in returning briefly to pre-surrealist days in order to highlight the origin of certain constants in surrealism.

Apollinaire, in a letter addressed to Raoul Dufy in 1910, indicated that he had as his motto: 'I astonish!' Some fifteen years later Breton wrote: 'Let us speak out: the marvellous is always beautiful, anything marvellous is beautiful, there is even only the marvellous that is beautiful.' And that is the very basis of the surrealist quest: marvel, but as conceived by poets, borne by the image, and charged with the desire to transmute the real.

I should mention that Apollinaire found the marvellous among the painters – fauves, cubists, futurists, orphics – because they made beauty spring out of 'a new source: surprise'. Rimbaud's affirmation, 'We must be absolutely mo-

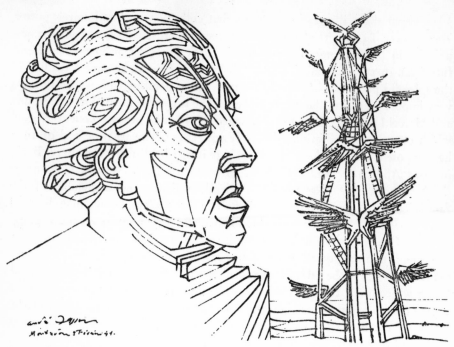

Portrait of André Breton, drawing by André Masson, 1941.

dern!', was applied to the letter by Apollinaire and, still more systematically, by the surrealists. Novelty, 'surprise', was a permanent concern of theirs, whether they were poets, painters, or both.

It was also, after Rimbaud and Mallarmé, a new conception of the image that Apollinaire and his followers valued. Apollinaire's friend Pierre Reverdy, a poet less known but equally notable, wrote:

> The image is a pure creation of the spirit. It cannot be born of a comparison but of the bringing together of two realities which are more or less remote. The more distant and just the relationship of these conjoined realities, the stronger the image – the more emotive power and poetic reality it will have.
>
> *Nord-Sud,* March 1918.

Reverdy, who found his form of expression through solitude and mental discipline, had a profound influence on the surrealist poets. His notion of 'the bringing together of two remote realities' was to constitute another basis of the surrealist aesthetic, in poetry as in art.

For Breton and his friends, the legacy of Apollinaire in art was: Picasso, that supreme magician of surprise; Henri Rousseau, the visionary of a child-like purity; Chagall, who 'transfigures modern torment' (Breton, *Genesis and Perspective of Surrealism*, New York, 1941); Picabia, talented juggler and master of sarcasm; and Duchamp, meta-logician of the image, of whom Apollinaire said that his work tended to 'reconcile art and the public'. We can consider separately the case of Chirico, who, despite being one of the founding fathers of surrealism in painting, changed directions after 1917 and became the subject of passionate controversies. Chagall himself was long held under suspicion because of his 'mysticism', and justice was done to him only much later. Picabia, who could not attend without derisive laughter the formation of a 'group' acting according to a 'discipline', was the object of serious reservations. And Picasso, the man with the 'exceptional predestination' ('Surrealism and Painting' in *La Révolution Surréaliste*, No. 192), was rejected and vilified when he followed Louis Aragon and Paul Eluard into the ranks of the Communist Party.

Apollinaire's modernism, they became convinced, was eclectic. That of the surrealists was systematic.

Convulsive Beauty

The surrealists, founding their aesthetic on the hidden sources of inspiration, excluded from their ranks and spiritually condemned all art whose expression reflected a conception that was logical, rational, and in harmony with the universe. The line that connects the Greece of the Parthenon with Michelangelo, with Nicolas Poussin, Chardin and Cézanne, was not only strange to them – it was inimical.

Of Christian art, they recognized only the daemonic or heretical. Of Europe, they retained only the archaic periods – especially the Cretan and Mycenean – while favouring the more popular and primitive art. They valued most all that was bequeathed by Pre-Columbian America, as well as the arts – which were flourishing at the beginning of the century – of Negro Africa, Oceania, the American Indian and the Eskimo.

In this connection, a surrealist map of the world drawn in 1929 is extremely significant *(Variétés*, Brussels, June 1929). The only cities shown are Paris and Constantinople, but without France or Turkey. Europe consists only of Germany, Austria-Hungary and an immense Russia, which also takes up half of

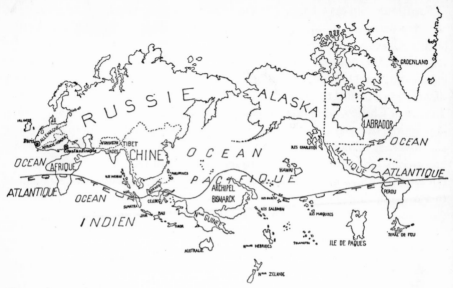

The surrealist map of the world.

Asia (the other half of which is composed of China, Tibet and an outsized Afghanistan next to a rather small India). By contrast, the islands of the Pacific occupy two thirds of the world and carry as banners the marvellous names of Hawaii, the Solomons, New Hebrides, New Zealand, the Marquesas and the Bismarck Archipelago. The North American continent, from which the United States is missing, presents a gigantic Alaska, the Charlotte Islands, Labrador and Mexico. Further down, Easter Island is as large as all of South America, which is reduced to one single country: Peru.

Childish as this drawing of a imaginary world (considered to be the only desirable one) may be, it corresponds to the permanent orientation of the surrealist ideal. That ideal tends to challenge Western Christian civilization, born of the fusion of the Greek spirit and Hebrew monotheism. The surrealists would gladly have sacrificed all Romanesque art, the cathedrals, the châteaux of the Loire and Versailles in favour of the statues on Easter Island. I am speaking now of the orthodox surrealists, fanatically faithful to André Breton and his tastes elevated into doctrine.

For André Breton, the element of surprise advocated by Apollinaire did not take long to express itself. Borrowing Lautréamont's definition of beauty – 'Beautiful as the unexpected meeting, on a dissection table, of a sewing machine and an

umbrella' – he made the removal of objects from their normal context the basic element of surprise. The primitive or 'savage' arts whose forms – masks or sacred objects – remained closely tied to mythical representation or to magical power corresponded naturally to this ability to 'derail' the mind, which the surrealists claimed as their goal. 'There is not a work of art', wrote Breton, 'which can stand up to our integral primitivism' ('S. and P.' in *R. S.*, No. 4).

The surrealists, having condemned all formal procedure in Western art, staked everything on the *unusual*, on surpassing the real, either by the introduction of the dream or by abandoning themselves to the interior model. Baudelaire had already written: 'The beautiful is what is bizarre' (Universal exhibition of 1855, in *Aesthetic Curiosities*). Furthermore, it should be noted that the Romantics in Germany and France were fully aware of what Breton and his friends designated several decades later as surrealism. They had simply more respect for tradition and the past, and did not deny all value to the logical system.

Nevertheless, they did invent the terms *surnaturalism* and *supernaturalism*, in which very similar conceptions are to be found. Notably, Heinrich Heine said: 'In art, I am a supernaturalist. I believe that the artist cannot find all his types in nature, but that the most remarkable ones are revealed to him in his soul, as the innate symbolism of innate ideas and at the same instant' *(Französische Zustände*, 1831). Nerval, who experienced more frequently than anyone else what he called 'the effusion of the dream in real life', said of one of his poems that it was 'composed in a state of supernaturalist reverie, as the Germans would say' (Nerval, *Les Filles de Feu*, Paris, 1954). Victor Hugo used the term on several occasions: 'The complete poet is composed of three visions: Humanity, Nature, Surnaturalism. For Humanity and Nature, Vision is observation; for Surnaturalism, Vision is intuition' *(Complete Works*, Ed. de L'Imprimerie Nationale, *William Shakespeare*, Paris, 1937).

Hugo stated his thought precisely in *Postscript to My Life (Idem)*: 'It is academic and official science which, in order to settle the matter more quickly and in order to reject as a whole all that part of nature which is not perceptible to our senses and which consequently frustrates observation, has invented the word *surnaturalism*. We adopt this word, it is useful for distinguishing; we have already used it and we will use it again but, properly speaking and in the strict sense of language, let us state once and for all: the word is empty. There is no surnaturalism. There is only nature ... There is the part of nature that we perceive, and there is the part of nature that we do not perceive.' In a more concise manner, in *The Workers of the Sea* (1866), he took up the same idea once again: 'No surnaturalism whatever, but the continuation of indefinite nature.'[1]

Drawings by Victor Hugo.

I feel that this calling into question of the notion of surnaturalism (although recognizing the usefulness of the term to designate that which escapes the senses and reason) can validly be applied to the notion of surrealism, a word which designates, on the whole, a reality that cannot be apprehended by the traditional methods of knowing. Breton expressed a similar idea when he wrote: 'All that I love, all that I think and feel, inclines me towards a particular philosophy of immanence according to which surreality would be contained within reality itself (and neither superior nor exterior to it)'.

But, to counterbalance the privileged position most of us – writers and artists included – would give to the rational, to common sense, to a beauty that might be called tame, Breton and the surrealists turned their attention to plumbing the depths of the night: the unconscious and the dream. They demanded an art expressing either desire in its raw state or unrestrained inner turmoil, or else a clear desire to go beyond the real. What they called automatism bears an astonishing resemblance to what the German romantic philisophers called

somnambulism, passive consciousness, or even 'the Involuntary'. ('All our actions are a kind of somnambulism, that is to say, answers to questions; and it is we who are questioning ourselves', wrote J. W. Ritter.) In France, Hugo made currents talk; he made waves, turntables, ink blots talk. Rimbaud abandoned himself to 'simple hallucination'. The special attention paid by the surrealists to the works of the mentally ill (A. Breton, *The Art of the Insane: the Key to Freedom* in *Cahiers de la Pléiade*), finds its distant counterpart in a fragment from Novalis: 'There exist great resemblances between madness and enchantment. The enchanter is an artist of madness.'[2]

Picasso, *April Fool*, 1936.

Finally, the surrealists asked their poets and their painters to know how to enchant, which, properly speaking, is a magical process. There must be between the work and the spectator a 'clicking', a shock, a current, which acts and transforms. 'Beauty', stated Breton, 'will be convulsive or it will not be.'

The Initiators

Pablo Picasso was at first counted as one of the greatest enchanters; the fervent pages which Breton devoted to him in *Surrealism and Painting*[3] bear witness to this. He was certainly the greatest agitator which Western art has known. The influences on Picasso were not limited to archaic and native sources, whose greatness he realized; they also extended to classical sources, whose initial vigour he recaptured. Just as was demanded by Hugo's definition of the complete poet, Picasso's vision, neither realistic nor abstract, succeeded in blending observation and intuition in a single impulse. What he learned from Ingres and Cézanne was in no way more important to him than what he learned from Negro Africa and the Greeks. No doubt he received the acclaim of the surrealists in good faith, but it is certain that he would never have subscribed to the polemic judgments expressed by Breton, for example, concerning ancient masters: '. . . Pale Rembrandt and sad Rubens', and 'Delacroix, able creator of rather empty romantic illustrations' (A. Breton, *L'Art Magique*, Paris, 1957).

In any case, according to the texts, in 1925 Picasso appeared not only as the principal initiator of surrealism in art, but also as the one in whom was placed the most unqualified confidence. Witness the sublime terms used by André Breton in speaking of him: 'His admirable perseverance is a token so precious to us that we can decline calling on any other authority . . . *The Man with the Clarinet* remains as tangible proof of that which we continue to advance, the knowledge that the spirit obstinately speaks to us of a *future continent* and that everyone is in a position to accompany an ever-more-beautiful Alice to Wonderland . . . Only someone with no idea at all of Picasso's exceptional predestination would dare to fear a partial renunciation from him . . . O Picasso, you who have brought to its supreme degree the spirit, not of contradiction, but of evasion: You have allowed to hang from each of your paintings a ladder of cord, even a ladder made with the sheets from your bed, and it is probable that you as well as we are seeking only to come down, to climb up from our sleep.' (*Surrealism and Painting*, pp. 26–28.)

It must be said, in spite of the reservations or the controversies it may provoke, that *Surrealism and Painting* remains – through its energy, its tone, the fitness of its formulas, and the grace of its style – one of the finest volumes of art criticism known today, precisely because it goes beyond formal criticism and, over and above the works of art, deals with the man. Without doubt it constitutes the essential and indispensable reference book on this subject.

In this book, as in the Manifesto, controversy is combined with poetry: surrealism bids farewell to Derain and Braque, not without regret, but violently rejects Chirico, 'insulter of his youth'. Chirico, however, could be considered an even greater source of inspiration to surrealist art (through his earlier work) than was Picasso. Between 1911 and 1913 Chirico wrote: 'For a work of art to be truly immortal, it must completely go beyond the limits of the human; common sense and logic will fail. In this manner it will approach the dream and the mentality of childhood.' And also: 'The profound work will be drawn up by the artist from the furthest depths of his being; there no murmur of a brook, no song of a bird, no rustle of a leaf takes place.' (Quoted by Breton, *S. and P.,* pp. 45–46.)

In fact, the works of Chirico – arcades or porticoes, enigmas, metaphysical interiors, rather than paintings properly speaking – appear to us as the tracings of a dream, or as a reality perceived outside the senses by some other self. This theatre for the materialization of shadows seems to us a better answer to the surrealist quest than Picasso's moving universe, which plunges into reality and transmutes it. Without great concern for the art of painting, Chirico has depicted the place (generally deserted), the statues, the things, but by diverting them from their rational ends in order to restore to them their being, which is precisely the object of the surrealist movement. No one, in truth, has defined this process more precisely than Yves Bonnefoy: 'When surrealist thought took pleasure in reuniting, after the *Songs of Maldoror,* the sewing-machine and the umbrella on the dissection table, those three objects remained specifically the instruments that we know by the integrity of their structure, which was at once abstract and rigorously defined. This structure, however, because of the obliteration of the rational perspective caused by the bizarre combination, henceforth appeared opaque, irreducible to its own meaning or to any other, and the reunited objects became mysterious, carrying us by their purposeless existence to a new form of astonishment. The thing which its usage had made interchangeable and nearly invisible – absent, in a word, and drawing us along into its absence – saw itself endowed with *presence,* if I may designate by this word the pure evidence of the fact of being, itself such a stranger to any cause, either formal or material, that we can consider it an absolute in respect of which every necessity and even every natural diversity are nothing but illusions.' (Y. Bonnefoy, *Dualité de l'Art d'Aujourd'hui,* Arts de France, No. 11, 1961.)

Did Chirico, the great exponent of the dream, one day decide he wanted to paint 'like Renoir'? Certainly he lost the state of grace to the extent of no longer seeing in the poignant assemblages of his youth anything but still lifes of a parti-

cular kind. The fury of the surrealists and their insults to this 'turncoat' can only be explained as disappointed love.

With Francis Picabia there was always that mixture of disdain and sarcasm, of disillusionment and irony that the young surrealists liked so much and that they glorified in Jacques Vaché, for example. An inexhaustible capacity for refusal, a light-hearted manner that was sometimes mocking, sometimes bitter-sweet, the impatient quest for a trigger, for a surprising discovery – these characterize the work of this noctambulist dandy of whom Robert Lebel sketched this interesting portrait: 'With that comical majesty to which he holds the secret, Picabia will espouse every style, including the worst, thereby demonstrating that everything is possible and that everything is worthwhile. Pushing desacralization to its extreme, he will be occupied with the unheard-of and the trivial, will testify that, from a certain point of view, there is no basic difference between a rather commonplace Spanish portrait and "one of the most exceptional paintings in the world"; he will rise to the loftiest poetic heights, and will counteract it by the about-face of a pun, and eventually finds himself, in his seventies, always well ahead of his century, always inconsistent, always available, always marvelling and laughing up his sleeve at the seriousness and immobility of others and their faithfulness to the formula which they have patented'. (R. Lebel, 'Picabia and Duchamp or the Pro and Con', November, 1949.)

The need to 'desacralize' of which Picabia gave evidence all his life did not spare surrealism, and it was with his tongue in his cheek that he observed the 'movement' created by his young friends of *Littérature*. In 1925 Breton payed homage to Picabia, but deplored 'his perfect incomprehension of surrealism' (*S. and P.*, pp. 48–49). It is nonetheless true (and unchallenged) that the routes of surrealism pass through Francis Picabia. He was one of the first to play systematically with chance and to reduce to a minimum the time which separates the conception of a painting from its realization. His imaginary 'machines' with toothed wheels turned by transmission belts, his constructions of matches, string and toothpicks out of which spring forth the face of a woman or a vase of flowers: these are very rare sparks amidst an undergrowth through which no path, before his passage, had been traced.

One year after the publication of the Manifesto in 1929 Marcel Duchamp, who was nearing forty, interrupted an already prodigious *œuvre* and gave up painting, leaving incomplete the 'large glass', *The Bride Stripped Bare by Her Bachelors, Even*, on which he had been working for eight years. His work from 1911 to 1918, on the border of the cubist and futurist movements, was involved

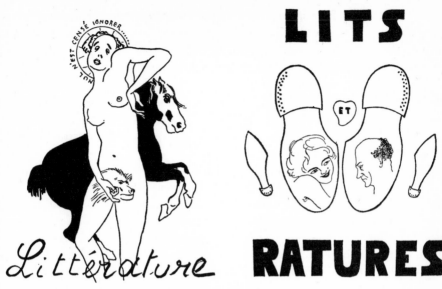

Cover drawings for *Littérature* by Francis Picabia ('Nude woman with horse', October 1922; 'Lits et Ratures', December 1922).

well beyond in the regions of the possible with a calm audacity and an unfailing lucidity. The analysis of Duchamp's work by Robert Lebel in his essay *Sur Marcel Duchamp*, (Paris, 1959) is the most intelligent and most complete we have. Duchamp's voluntary retirement in his full maturity, at a time when his exceptional qualities as a painter were unquestioned, gave the figure of the painter a legendary character. 'He invented', wrote Lebel, 'a way of being absent that Rimbaud had not even suspected. To his "irony of affirmation" one longs to add the "positive retreat" or the "constructive denial", so full of implications are his undertakings which at first glance seem detached. It is at the same time the gratuitous act and its opposite, the relief of having broken with the others and the impossibility one finds, in profound solidarity, of concealing completely one's consternation before what continues.' (R. Lebel, *loc. cit.)*

André Breton, who met Duchamp in 1922 and hailed him in lordly terms (*Litt.*, n. s., No. 5), was to repeat this homage in relation to the 'large glass' in an essay entitled '*Phare de la Mariée*' (*Minotaure*, No. 6, Paris, 1936). 'It is impossible not to see [in this work]', wrote Breton, 'at least the trophy of a fabulous hunt over virgin lands, on the borders of eroticism, of philosophical speculation,

of the spirit of sporting competition, of the latest findings of science, of lyricism, and of humour' (*S. and P.*, p. 113). In truth, Duchamp was always to enjoy a place at the heart of surrealism that was all the more privileged for never having been solicited. Whereas so many others, for motives that were sometimes futile, were more or less ignominiously expelled, Duchamp was never reproached for his faithfulness to the 'excluded', for his lack of political bias, nor even for his acceptance by the National Academy of the United States, which is, for that country, the institution closest to the French Academy and the Academy of the Beaux-Arts combined.

The work of Duchamp, especially *The Bride Stripped Bare*, combines in a very subtle manner emotional impulses (sometimes dating back to his childhood), the results of chance carefully recorded (*canned chance* he called it), scientific formulas warped, diverted from their function, and endowed with a *para-logic* meaning, and finally his ability to look at himself without indulgence, thus engendering humour. The result of this complex association is *The Bride*, undoubtedly the most enigmatic work in modern art, and which the surrealists honoured as it deserved.

It is appropriate to consider, midway between Picabia and Duchamp, the very particular contribution of Man Ray, the first American Dada and surrealist painter. Besides the fact that he re-invented photography – a technique to which his ingenuity opened countless possibilities – and endowed it with the wings of poetry, he was also a precursor as a painter (already prominent between 1913 and 1917 in Ridgeway and in New York) and a tireless inventor. Better than

Joan Miró, *Automaton*, 1924.

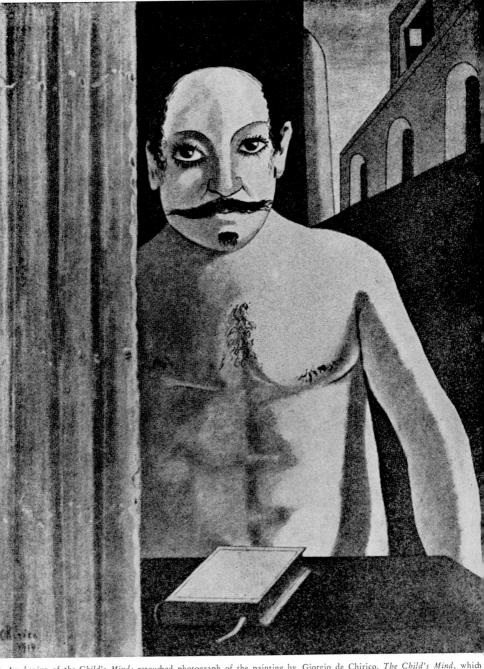

Awakening of the Child's Mind: retouched photograph of the painting by Giorgio de Chirico, *The Child's Mind,* which eared in the *Almanach Surréaliste du demi-siècle,* Paris, 1950

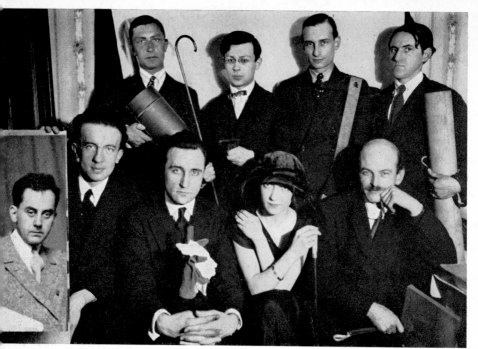

The *Littérature* group in 1922. Standing, left to right: Paul Chadourne, Tristan Tzara, Philippe Soupault, Serge Charchoune. Seated, left to right: Man Ray (Collage), Paul Eluard, Jacques Rigaut, Mick Soupault, Georges Ribemont-Dessaignes

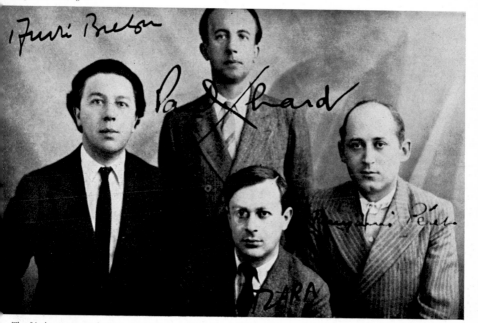

The *Littérature* group in 1922: André Breton, Paul Eluard, Tristan Tzara, Benjamin Péret

orges Malkines, André Masson, Max Morise and Georges Neveux in Thorenc (Alpes Maritimes), 1923

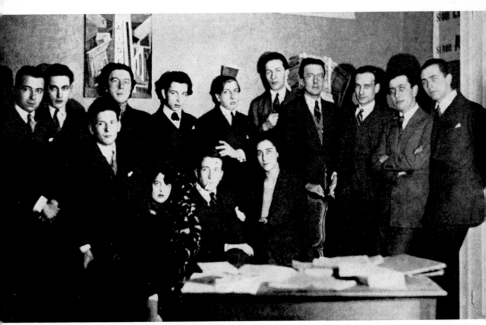

gathering of surrealists, 1924. Standing, left to right: Charles Baron, Raymond Queneau, Pierre Naville, André Breton,
A. Boiffard, Giorgio de Chirico, Roger Vitrac, Paul Eluard, Philippe Soupault, Robert Desnos, Louis Aragon. Seated,
 to right: Simone Breton, Max Morise, Mick Soupault

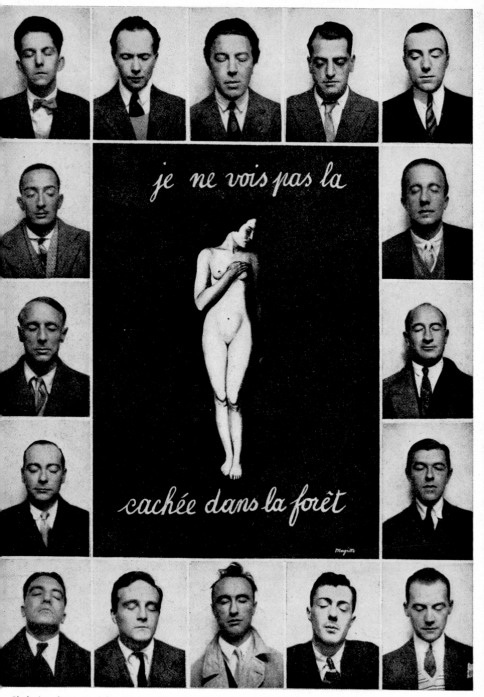

je ne vois pas la

cachée dans la forêt

Clockwise, from top left: Maxime Alexandre, Louis Aragon, André Breton, Luis Buñuel, Jean Caupenne, Paul Eluard, Marcel Fourrier, René Magritte, Albert Valentin, André Thirion, Yves Tanguy, Georges Sadoul, Paul Nougé, Camille Goemans, Max Ernst, Salvador Dali. In the centre is a painting by René Magritte, 1929

7 Joan Miró, 1930

8 Belgian surrealists, 1926. Standing, left to right: E. L. T. Mesens, René Magritte, Louis Scutenaire, André Souris, Paul N
Seated, left to right: Irène Hamoir, Marthe Nougé, Georgette Magritte

ques Prévert, Simone Prévert, André Breton and Pierre Prévert in Paris, 1925

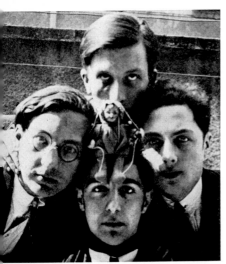

lockwise, from top: Roger Vaillant, Roger Gilbert-
ecomte, Robert Meyrat, René Daumal, 1929

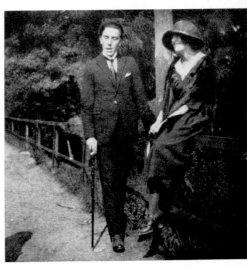

11 André and Simone Breton, 1920

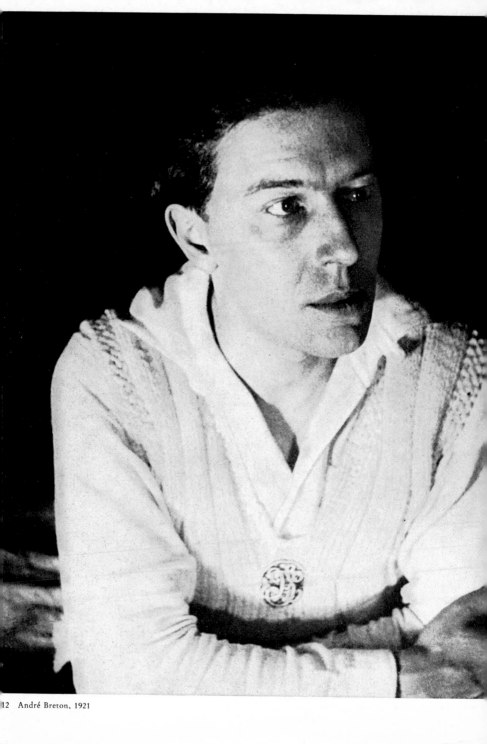

12 André Breton, 1921

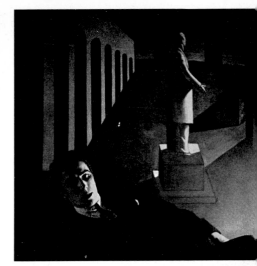

imone Breton, 1921

14 André Breton in front of a painting by Giorgio d
Chirico

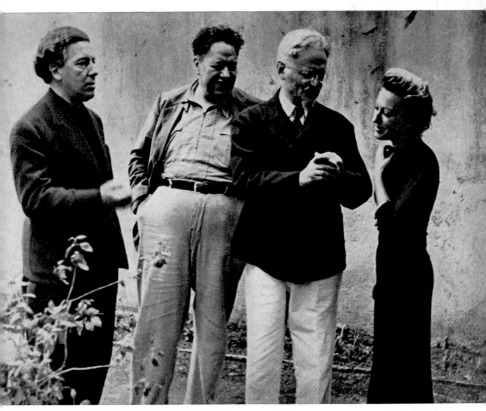

ndré Breton, Diego Rivera, Léon Trotzky and Jacqueline Breton in Mexico, 1938

16 André Breton in the grounds of the Marquis de Sade's castle Lacoste, Vaucluse, 1947

17 André and Elisa Breton, 1956

18 Man Ray, 1931

is Picabia, 1922

20 Robert Desnos and André Masson, 1923

21 Robert Desnos, 1922

22 Marcel Duchamp, 1958

ee Miller, Paul Eluard and Eileen Agar in Brighton, 1936

Marcel Duchamp and Man Ray, 1963

25 Paul and Gala Eluard, 1923

Louis Aragon and Théodore Fraenkel, 1919

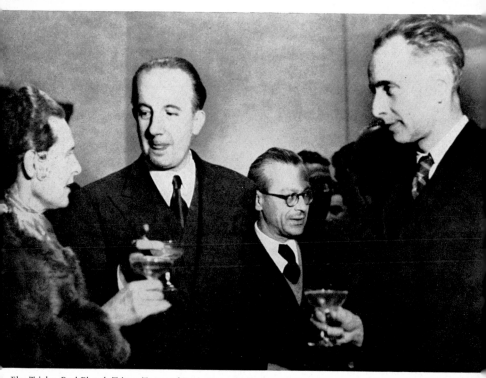

Elsa Triolet, Paul Eluard, Tristan Tzara and Louis Aragon in Toulouse, 1946

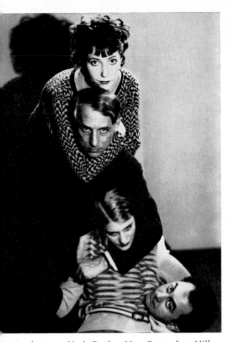

op to bottom: Marie-Berthe, Max Ernst, Lee Miller
nd Man Ray, 1931

29 Dorothea Tanning and Max Ernst in Sedona, Arizona, 194

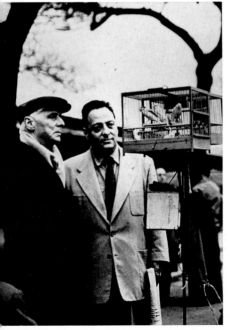

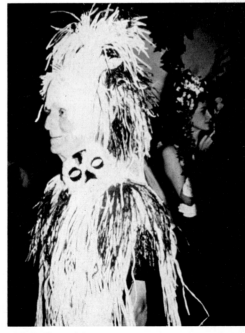

Max Ernst and Patrick Waldberg at the bird market in
aris, 1960

31 Max Ernst, 1959

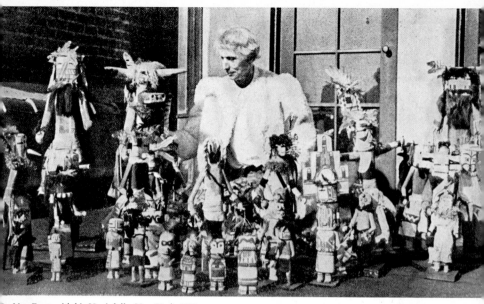

2 Max Ernst with his Hopi dolls, New York, 1942

Antonin Artaud in C. Dreyer's film, *The Passion of Joan of Arc*, 1928

34 Yves Tanguy, 1925

Max Ernst, *The Beautiful Season*, 1925. Frottage on paper, reproduced in the surrealist portfolio *Natural History*.

anyone else he succeeded in placing an object completely out of context; it was an art of 'practically nothing', which the philosopher Vladimir Jankelevitch would have liked, an art made up of chance encounters, logarithmic suitcases, rolls of cardboard falling in endless spirals, loaves of bread 'repainted' with enamel, Shakespearian equations. He was the progenitor – but how much more delicate and subtle – of a great number of expressions which are very popular today. *La Révolution Surréaliste*, like *Littérature* before it, owes him its most beautiful pictures.

'Beyond Painting'

Between the two poles of a somnambulistic Chirico dedicated to 'the dream and the childish mentality' and a Duchamp superlatively aware, attempting to substitute pure behaviour for art, there soon appeared a number of artists who were equally determined not to pay attention any longer to the former rules of the game.

These men had come from very different backgrounds and surroundings: Max Ernst from the Rhineland, Jean Arp from Alsace, André Masson from Picardy, Yves Tanguy from Brittany, Joan Miró and Salvador Dali from Catalonia, René Magritte from Wallonia. They did not gather together for the purpose of experimenting with a manner of painting, but rather with a manner of living. At the meetings of the poets, all answered: 'Present!' Were they not themselves poets, drunk with a youthful liberty, whose limits only their enthusiasm kept them from measuring accurately? 'Drop everything', Breton cried. 'Sow your children in the corner of a wood . . . Let go the prey, for the shadow . . . Set out on the road' (*Litt.*, n. s., No. 2). Philippe Soupault, looking somewhat haggard, would ring doorbells and ask the concierges 'if Philippe

Two drawings by Max Ernst, 1925. Left: *Easy*. Right: untitled. Frottage on paper, reproduced in *Natural History*.

Soupault did not live there'. Benjamin Péret would insult priests on the street. Paul Eluard, without warning, sailed for the Orient, where he was soon joined by Max Ernst. Robert Desnos went into trances at Breton's house. Georges Limbour, famished and simulating Desnos's trance, would get down on all

Surrealist drawing by Jean Arp.

Jean Arp, *The Watch*, 1932.

fours, bark, and eat the dog's food. Louis Aragon sang softly: 'No, I won't go home.' Jacques Prévert, at night dressed as a hooligan, would lead astray the innocent passer-by in the bourgeois quarters. Tanguy captured spiders, which he ate alive to terrify the neighbourhood. Dali, whose moustache was still young, gave lectures at the Sorbonne with his bare right foot soaking in a pan of milk. From time to time they would strike a critic. At night the streets were full of nymphs, and luminous posters announced destiny. It was the time of euphoria and extravagance, but not to the exclusion of seriousness, which was always appropriate when it was a question of the revolution, of sex, or of surrealist projects for decorating the squares of Paris.

In this climate of intoxication, of more or less cyclic exaltation, work was accomplished. Some (Arp, Ernst) had anticipated surrealism long before it existed. As early as 1915 Jean Arp wrote, speaking of his works: '[They] are constructed with lines, surfaces, forms, and colours which seek to attain, beyond the human, the infinite and the eternal . . .' (Arp, *On My Way*, New York, 1948). Max Ernst, seeking 'the irritation of his visionary faculties', undertook as early as 1916 a re-interpretation of the visible world, often charged with muted emotions. He gave an historical account of the mental processes that stimulated the development of his work in a text that is excellent for the understanding of

André Masson, *Automatic sketch*, 1925/26. Drawing by Léonor Fini, 1959.

surrealism, *Au-delà de la peinture* (first published in *Cahiers d'Art*, 1936; M. Ernst, *Beyond Painting*, New York, 1948).

The beautiful 'automatic' drawings of André Masson, which appeared in every issue of *La Révolution Surréaliste*, could not make one forget the more general intentions of this artist, whose 'constant desire' has been defined by Michel Leiris as follows: '... to reunite in one work the four elements, just like the four realms (if one agrees with Novalis that *the celestial bodies constitute, beneath the stones, a fourth natural realm*), to make *a philosophy in a painting,* and may that painting no longer be a *magical operation,* but an *explanation of the universe.*' (André Masson, collected works edited by his friends, without mention of a publisher, printed in Rouen, 1940.)

In 1925 the 'silent and secretive' Joan Miró was nonetheless subject, like his new friends, 'to an almost delirious intellectual effervescence'. 'His painting', wrote Jacques Dupin, 'will be the immediate expression of the movements of being, their capture at the source, their passing over the canvas which is less the location of metamorphosis than the receptacle of dreams.' (Jacques Dupin, *Miró,* London, 1962).

Yves Tanguy, composing landscapes that were half-marine, half-lunar, blindly followed an impulse which issued forth from the very depths of his being. Within its plastic limits, his painting faithfully met the surrealist require-

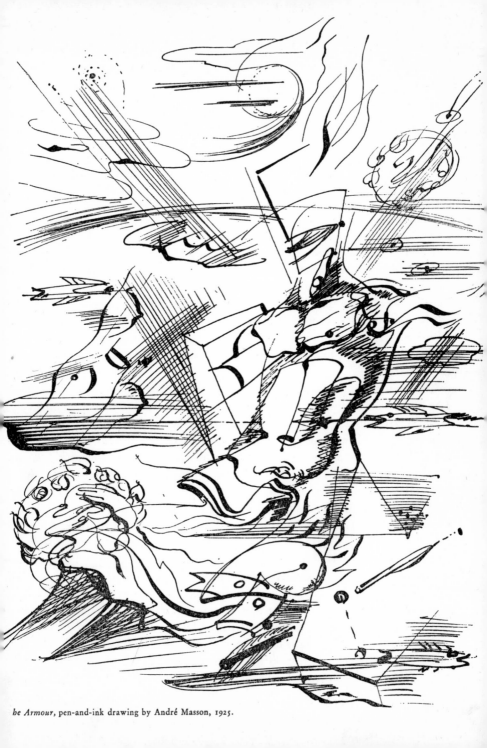

be Armour, pen-and-ink drawing by André Masson, 1925.

ment, having no other source than inner reality and patterned after the far-off memories of childhood. But whereas Tanguy continued the renunciation of Chirico, René Magritte came to swell in an original way the specifically intellectual current set in motion by Duchamp. There is, in fact, a definite relationship between Duchamp's 'ready-mades' (random objects selected from among the most common and presented under another name as works of art) and Magritte's speculations concerning both the identity and the function of things.

Salvador Dali, through his meticulous and delirious Freudian compositions, gave rise about 1929 to what André Masson called 'surrealist naturalism'. 'I am certain', wrote Masson, 'that it is high time to decide between the two types of surrealism: that of 1924–1928 in which the sign, the writing were preponderant, and the other surrealism (or surrealist naturalism) which followed. I believe that I remained faithful to the first movement, convinced that that expression had not said its last word.' (Quoted by F. Legrand, 'Painting and Writing', *Quadrum*, No. 13, 1962.) Dali, in any case, was the first to point out in essays – in which humour serves as a springboard for poetic invention – the unconsciously surrealist nature of numerous products to the 'modern' style, and the fascinating power of 'strange bodies in space'. He is also responsible, in collaboration with Luis Buñuel, for the first surrealist films, *Un Chien Andalou* (1929) and *L'Age d'Or* (1930).

The decade that preceded the outbreak of the Second World War (1929–1939) saw René Char's arrival as a poet and Alberto Giacometti's overwhelming constructions standing in space, with his trembling, nearly diaphanous figures petrified with solitude and anguish. I can only indicate here several points of reference. Victor Brauner – with his voodoo chimeras, exorcisms, incantations, and his recalling of forms formerly endowed with magical power – could easily have taken for himself the words of Mallarmé: 'I say that there exists between the old methods and the spell, which poetry will always remain, a secret parity.' (Mallarmé, *Divagations. Magie*, p. 326.) Jacques Hérold, for his part, subjected reality to the double refraction of crystal and of flame, and charged it with incandescent affectivity, answering that fine aphorism of Francis Ponge which he illustrated: 'The root of what dazzles us is in our hearts.' (F. Ponge, *Le Soleil Placé en Abîme*, Paris, 1954.) And finally there was Matta (Roberto-Sebastian Matta-Echaurren), the youngest of this constellation, whose equal surrealism was never to find again. In 1941 and 1942 Matta tore away from gravity and plunged into the ether. To the large canvases that he painted during that period, one could apply the description that Victor Hugo gave of an unearthly spectacle: 'The light had made of all that shadow suddenly come to life something

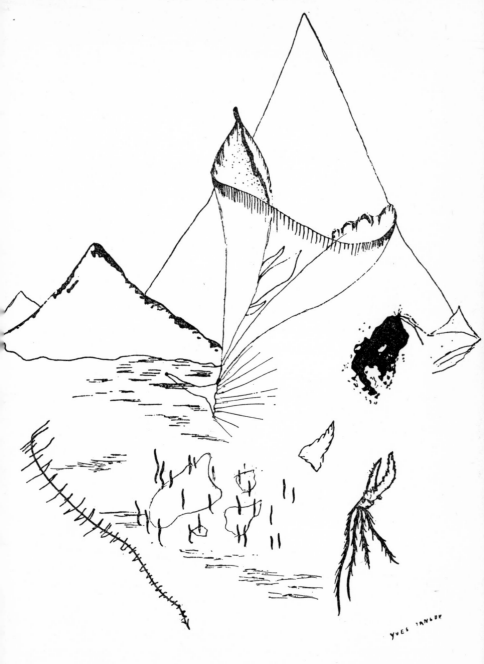

Drawing by Yves Tanguy, 1926.

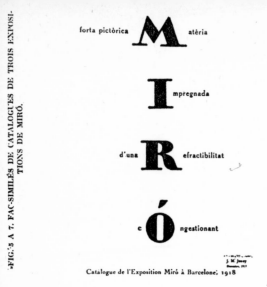

A page from the review *Minotaure* showing facsimiles from the catalogues of three Miró exhibitions.

like a mask that becomes a face. Every where gold, scarlet, avelanches of rubies, a rustling of flames. One would have said that the dawn had suddenly set fiire to this world of darkness.' (Hugo, *Promontorium Somnii, op. cit.*)

Thus, these artists, between 1924 and the Second World War, represented for the public surrealism in its plastic expression. Unlike the fauvist or cubist movements – whose works when juxtaposed indicate a certain 'family resemblance' and, in the search for colour and form, the mark of a common orientation – the surrealist works are, from the first, differentiated to such a degree that not even a temporary confusion is possible between an Ernst and a Miró, for example, or a Tanguy and a Magritte. The strongly personalized style of each of the protagonists can perhaps be explained by the fact that these painters, by the very nature of their approach avoiding tangible realy, stridently affirm their *particularity* – which did not prevent the work of the best among them from being accessible to the general public. What they do have in common, nevertheless, is the desire, overthrowing all barriers, to reach that 'beyond painting' that Max Ernst proclaimed as his goal.

Centralization and vaporization

There was at the origin of the surrealist movement a collective desire for action, bearing both on the surpassing of literature and of art and on the social transformation of the world – a desire nourished by heterogeneous sources which were, in the last analysis, irreconcilable. Besides the poetic references already mentioned, the movement claimed to be influenced by Hegei (often at second- or third-hand), Marx, Freud, Revel's speculations on chance, Flournoy's mediums, and Myers's metaphysics. For some of them, the ways of truth passed through the Orient. It was especially so in the case of Antonin Artaud ('Address to the Dalai Lama', *R. S.*, No. 3) and of the participants in *Le Grand Jeu* (1926–1928): René Daumal, Roger Gilbert-Lecomte, Joseph Sima and Maurice Henry. But as early as 1924 Breton was writing: 'Orient of anger and of pearls! . . . You who are the shining image of my dispossession, Orient, beautiful bird of prey and of innocence, I implore you from the depths of the kingdom of shadows!' (quoted in *Point du Jour*, Paris, 1934)

No rigorous effort was made to blend these contradictory thoughts and disciplines into a satisfactory synthesis. However, in the 'laboratory' of surrealist research of 1925 the means of liberation were, as we have said, 'codified',

and expression together with methods were subjected to an orthodoxy which was all the more precarious for being founded on whimsy and caprice. The most explicit and precise reproach directed against Breton on this subject was formulated recently by a young poet whose argument was that 'André Breton's mistake is the eternal intellectual mistake, the fear of the risk, mistrust in the realm of true simplicity and in the *experience* of the total life, which laboratory experimentation cannot replace. *The eye exists in the primitive state:* that single phrase of Breton's magnificently contradicts the theoretical edifice with its Freudian basis that he erects and especially the codification of processes and techniques that he deduces from it' (J. Dupin, *op. cit.*). It is a fact that nearly all those who were surrealists left 'the Group' and carried on, each in his own way, an experiment which it was perhaps premature to attempt collectively.

The review *Minotaure* (1933–1938), where spirits anxious to 'demystify' the mystery (Roger Caillois) rubbed shoulders with those who wanted, on the contrary, to set up a scale of access to the *Mirror of the Marvellous* (Pierre Mabille). died one year before the war, after having registered the political agreement between Breton and Trotsky. The exile they shared in the United States saw the temporary reunion, in the review VVV (1942–1944), of Duchamp, Breton, Ernst, Masson, Matta, Tanguy, David Hare and various guests under the sign

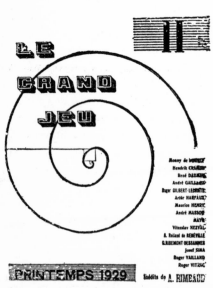

Cover of the Spring 1929 issue of *Le Grand Jeu*.

Cover of the Surrealist Exhibition catalogue, London, 1936.

Drawings by Yves Tanguy, 1926.

of a triple 'victory': material and moral, with the third serving to effect the synthesis of the first two.

After the war Breton and the Group, without relinquishing any of their anti-Christianity or frowning 'leftism', concentrated by preference on research in the hermetic and alchemist tradition. This orientation was already begun in the *Second Manifeste du Surréalisme* in 1930, in which Breton took up, almost to the letter, the formula of Hermes: 'Everything leads us to believe that there exists a spot in the mind from which life and death, the real and the imaginary, the past and the future, the high and the low, the communicable and the incommunicable will cease to appear contradictory.' *(Les Manifestes du Surréalisme,* Paris, 1962). The Second Manifesto, which, besides personal articles of self-justification, contains a fine and convincing defence of the rights of inspiration and free expression as contrasted with the narrowness of Marxist rationalism, concluded with this injunction: 'I request the profound, true occultation of surrealism.' And certainly the occult tradition, inherited from the Magicians, the Initiates and the Illuminated, played an increasingly larger role

in the surrealist programme, nourished in this domain not only by the classical texts, but by the contemporary works of Pierre Mabille, himself a Grand Initiate; Kurt Seligman, expert in sorcery; Malcolm de Chazal, Swedenborgian; Maurice Baskine, creator of 'phantasophy'; René Alleau, historian and analyst of the Tradition; and Eugène Canseliet, alchemist.

Since romanticism this current had continued to nurture poets. Baudelaire knew Eliphas Levi personally. Levi's *Dogmas and Ritual of High Magic* (1856) and *Occult Philosophy* (1862) were also consulted by Rimbaud, Villiers de l'Isle-Adam, Mallarmé and Jarry. Most of the symbolists thought highly of Saint-Yves d'Alveidre and Stanislaus de Guaita and the Rose-Croix of Joséphine Péladan must, on principle, have known Rosenkreuz's *The Chemical Wedding Feast*. It was, moreover, in the nineteenth century that poetry tended to become 'sacralized' and that the 'prophetic tribe' of poets (Baudelaire) found itself endowed with extra-lucid powers which were indispensable to the elaboration of an 'alchemy of the word' (Rimbaud).

The surrealist periodicals which appeared after the war register the renewal of interest in esotericism. *Néon* (1948–1949) had as successive mottoes 'To be nothing, To be everything, To open the individual' and 'To navigate, To awaken, To conceal.' The title of *Médium* (1953–1954) was explicit. *Bief* (1958–1960), *Le Surréalisme même* (1956–1959) and *La Brèche* (1961), which is still published, give evidence of the same preoccupations. Elsewhere references to Marxism, even in its Trotskyite form, became rarer, giving way to a certain political 'worldliness' of which Garry Davis's 'Citizen of the World' movement was one of the avatars (A. Breton, *La Lampe dans l'Horloge*, Paris, 1948).

André Breton's honourable and touching constancy in his search for understanding, and even for nonconformist wisdom, is difficult to reconcile with the pettiness and polemics found in the reviews that he directs. Although these attacks are often the doing less of Breton himself than of his zealots, he does not seem to notice the incongruity between these attacks and the eminently noble cause to which he has dedicated himself.

A similar incongruity – grand purposes and petty quarrels – has always characterized the surrealist group and this explains to a great degree the progressive disaffection of all those who were attracted by it. If this incongruity is accompanied, as seems to have been the case for several years now, by stagnation and the drying-up of inspiration, it is not surprising that the group today has such a small following.

Surrealism has for a long time acted as a kind of magnetic pole to which were drawn some of the most engaging personalities of the period. The contest of

temperaments and personalities, the perpetual transition from the positive to the negative and the vexations of a questionable discipline eventually drove each of these individuals back into his own sphere, and not without some commotion. From this galvanizing contact, the better armed were able to draw energy and to pursue alone an experiment which was all the more fruitful for having become free. Others came away enervated, dulled; some died of it.

The problem is to know whether surrealism consists of a private domain as Breton would wish, a paradise of several 'just men' for whom he would be St Peter and those of his group the Archangels, or whether, as is generally admitted, the movement is represented by all those in the world – outside the movement or sympathetic to it – who act and express themselves according to the surrealist *spirit* as I have described it in the preceding pages.

In the former case – that is to say, limited to the group and to its activities – surrealism still survives, certainly, but as a quasi-underground movement, and the rare occasions on which it surfaces make us fear for its health. In the latter case, surrealism – taken in a broader sense – has kept a universal scope which the group alone would not have been able to maintain. The considerable prestige of Marcel Duchamp in the United States, the increasing interest of the youth of all countries in the work of Max Ernst, the perennial influence of Miró, Masson and Matta, to mention only a few, indicate to what extent the surrealist idea has remained alive.

Its present situation has been very properly evaluated by Maurice Blanchot: 'It (surrealism) is not much a school, but a sate of mind. Nobody belongs to this movement, but everybody is a part of it. Is surrealism disappearing? No, because it is neither here nor there: it is everywhere. It is a phantom, a brilliant obsession which, by a wonderful transformation, has become surreal.' (M. Blanchot, *La Part du Feu*, Paris, 1944).

Such they where, such they are still – the ways of surrealism, winding past regions sometimes formidable, sometimes charming, the attractions of which are always unforeseen. They travel through a vast land of *recreation* (in both senses of the word) where the subjects of the most fascinating 'truant movement' ever to have given rise to literature and art frolic, converse, meditate and dream.

PATRICK WALDBERG

N° 8 — Deuxieme année 1 Décembre 1926

LA RÉVOLUTION SURRÉALISTE

CE QUI MANQUE C'EST LA

A TOUS DIALECTIQUE

CES MESSIEURS (ENGELS)

ADMINISTRATION : 16, Rue Jacques-Callot, PARIS (VIᵉ)

ABONNEMENT,
les 12 Numéros :
France : 55 francs
Etranger : 100 francs

Dépositaire général : Librairie GALLIMARD
15, Boulevard Raspail, 15
PARIS (VII)

LE NUMÉRO :
France : 5 francs
Étranger : 7 francs

Title page of *La Révolution Surréaliste*, No. 8, 1926.

La Révolution Surréaliste

From *La Révolution Surréaliste*, No. 1, December 1924

EDITORIAL BY J.-A. BOIFFARD, P. ELUARD, R. VITRAC

As the trial of knowledge is no longer relevant and intelligence no longer need be taken into account, the dream alone entrusts to man all his rights to freedom. Thanks to the dream, the meaning of death is no longer mysterious, and the meaning of life becomes unimportant.

Each morning in every family, men, women and children, *if they have nothing better to do,* tell each other their dreams. We are all at the mercy of the dream and we owe it to ourselves to submit its power to the waking state. It is a terrible tyrant garbed in mirrors and flashes of lightning. What is pen and paper, what is writing, what is poetry before this giant who holds the muscles of clouds in his own muscles? You are there stammering before the serpent, ignoring the dead leaves and glass traps, fearing for your fortune, your heart and your pleasures, and in the shadow of your dreams you look for all the mathematical signs which will restore to you a more natural death. Others – and these are the prophets – blindly guide the forces of night towards the future; dawn speaks through their mouths and the ravished world is either frightened or satisfied. Surrealism opens the doors of dream to everyone for whom the night is miserly. Surrealism is the crossroads of the enchantments of sleep, alcohol, tobacco, ether, opium, cocaine, morphine; but it is also the breaker of chains. We do not sleep, we do not drink, we do not smoke, we do not sniff, we do not puncture ourselves: we dream, and the speed of the lamps' needles introduces to our minds the marvellous deflowered sponge of gold. Ah! if bones were inflated like dirigibles we would visit the shadows of the Dead Sea. The road is a sentinel erect against the wind which embraces us and makes us tremble before our fragile rubied appearances. You, stuck to the echos of our ears like the octopus-clock on the wall of time, you can invent pitiful tales which will make us smile nonchalantly. We no longer bother. There is a good line: *the*

idea of movement is above all an inert idea (Berkeley), and the tree of speed becomes visible to us. The mind spins like an angel and our words are the lead beads which kill the bird. You to whom nature has given the power to turn on the electricity at noon and stay under the rain with sun in your eyes, your acts are gratuitous, ours are dreams. Everything is whispers, coincidences; silence and brilliance ravish their own revelation. The tree loaded with meat which rises among the paving stones is supernatural only in our astonishment, but the time for closing the eyes has not yet begun.

Every discovery changes nature, the destination of an object or a phenomenon constitutes a surrealist deed. Between Napoleon and the phrenologist's bust which represents him there are all the battles of the Empire. Far be it from us to exploit these images and modify them in a sense which could imply progress. As many satisfying images and worthless inventions as alcohol, milk, or gas for lighting may appear from the distillation of liquid. No transformation takes place but, nevertheless, the writer who uses invisible ink will be counted among the missing. Solitude of love, the man lying on top of you commits a perpetual and fatal crime. Solitude of writing, you will no longer be known in vain, your victims caught up in the gears of violent stars come back to life in themselves.

We declare the surrealist exaltation of mystics, inventors and prophets, and we go on.

In addition, reports of inventions, fashion, life, the fine arts and magic will be found in this review. Fashion will be discussed according to the gravitation of white letters on nocturnal flesh, life according to portions of day and perfumes, invention according to the players, the fine arts according to the skate which says 'storm' to the centenarian cedars' bells, and magic according to the movement of the spheres in blind eyes.

Already the automatons multiply and dream. In cafés they quickly demand writing materials, veins of marble are the graphics of their flight and their cars go to the Bois alone.

Revolution ... Revolution ... Realism is the pruning of trees, surrealism is the pruning of life.

V. Max Ernst, *Dove,* 1928

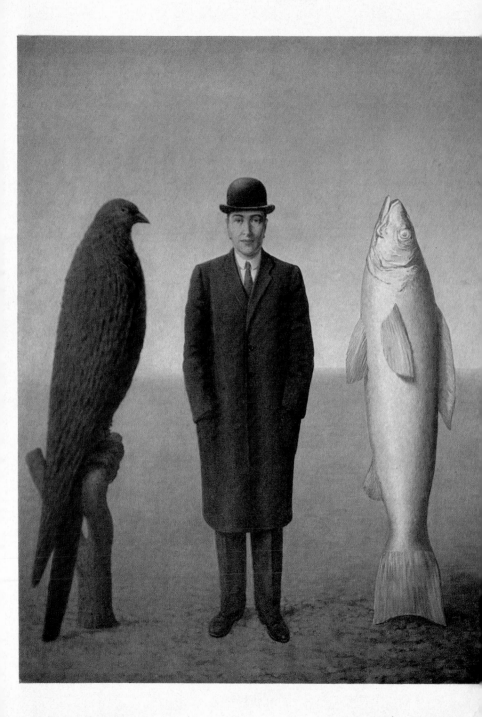

From *La Révolution Surréaliste*, No. 2, January 1925

OPEN THE PRISONS DISBAND THE ARMY

There are no common-law crimes

Social coercion has had its day. Nothing, neither recognition of an accomplished fault nor contribution to the national defence, can force man to give up freedom. The idea of prison and the idea of barracks are commonplace today: these monstrosities no longer shock you. The infamy lies in the calmness of those who have got round the difficulty by various moral and physical abdications (honesty, sickness, patriotism).

Once conscience has recovered from the abuse which composes one part of the existence of such dungeons – the other part being the degradation, the diminution that they engender in those who escape from them as well as those imprisoned there; *and there are, it seems, some madmen who prefer the cell or the barrack-room* – once this conscience is finally recovered, no discussion can be recognized, no recantation. Never has the opportunity to have done with it been so great, so don't mention opportunity to us. Let the assassins begin, if you wish; peace prepares for war, such proposals conceal only the lowest fear or the most hypocritical desires. Let us not be afraid to acknowledge that we are waiting, that we are inviting catastrophe. Catastrophe? That would be the persistence of a world in which man has rights over man. Sacred union before knives or machine guns, how can this disqualified argument be cited any longer? Send the soldiers and convicts back to the fields. Your freedom? There is no freedom for the enemies of freedom. We will not be the accomplices of gaolers.

Parliament votes for a mangled amnesty; next spring's graduating class will depart; in England a whole town has been powerless to save one man; it was learned without great surprise that in America the execution of several condemned men had been postponed until after Christmas *because they had good voices*. And now that they have sung they might as well die, for the exercise. In the sentry boxes, in the electric chairs, the dying wait; will you let them go under?

OPEN THE PRISONS DISBAND THE ARMY

DEATH: THE OAKEN RAMPART

Robert Desnos

It is the Cadum baby eternally smiling on the wall, it is Robespierre's sublime sentence: *'Those who deny the immortality of the soul do themselves justice'*, it is the laurel wreath yellowing at the foot of a voluntarily mutilated column, it is the bridge's reflection, it is the umbrella sparkling like a sea monster and seen on a rainy day from the fifth floor. Did you once believe in the immortality of the soul, vanished demagogue? Immaterial to me; every assurance is inadequate here. Anxiety alone implies some nobility. Besides, immortality is impure; only eternity is worth considering. It is shocking that the majority of men link the problem of death to that of God. Whether the latter is a celestial and problematic Assayer, a superstition attached to a fetish rather poetic in itself (crescent, cross, phallus or sun) or an infinitely respectable belief in a realm of successive infinities, I shall always, in the name of human will, consider his funereal intervention a swindle.

He who does not doubt the non-existence of God renders concrete his inadmissable ignorance, as understanding of the spiritual elements is spontaneous. He who believes in God is almost always a coward and a materialist limited to his own physical appearance. Death is a material phenomenon. To have God intervene is to materialize him. Death of the mind is an absurdity. I live in eternity in spite of the ridiculousness of such a declaration. I believe I live, therefore I am eternal. Past and future serve matter. Spiritual life, like eternity, is conjugated in the present tense.

If death touches me, it is not in regard to my thought or mind, which the finest hearse cannot convey, but to my senses. I do not imagine love without the taste of death, cleansed of all sentimentality and sadness, as part of it. Marvellous satisfactions of sight and touch, perfections of pleasure – it is by your mediation that my thought can be in touch with death. The fugitive character of love is also that of death. If I sing the praises of one, I am beginning those of the other. Oh, women loved! You whom I have known, you whom I know: you, flamboyant blonde whose dream has haunted me for two years; you, brunette, covered with sacred furs; and you, too, whom I persist in meeting and following to various quarters, you who suspect my notions without sympathy, woman of thirty years, girl of twenty years, and the

others ... I entrust my funeral to you all. A funeral as it should be, good and grotesque and ridiculous, with yellow flowers and Père Ubu's Palotins as undertaker's men!

Unless from here to there ...

The fugitive character of love is also that of death.

Drawing by
Maurice
Henry, 1934.

ETHICAL SCIENCES: FREE TO YOU!

There is no freedom for the
enemies of freedom.

LOUIS ARAGON

Freedom ... after a thousand catastrophes, great confusion and the defeat of his simplest steps ahead, man, discouraged, begins to shrug his shoulders. That word is as provocative as fire. You do not have two eyelids in order to look freedom in the face.

At first the individual does not suspect his dependence. Obviously he knows that he can stretch out an arm if he wants. To him everything is a matter of will. Over several centuries doubt appears, is precisely stated, and finally the individual reaches the absolute determinism in which we find him entombed today. It is here that we remain, at this moment in human meditation; and yet how can the mind have hit upon its boundaries at one point alone and there, as elsewhere, confine itself – though apparently with good reason – to a vague sentiment raised to the dignity of an idea? How can one conviction check the movement of the mind? Will a new affirmation of freedom not emerge from determinist dogma? Freedom transfigured by its opposite: beside these troubled waters I wait for its divine features to become transparent under the spreading ripples of the inevitable, under the loosened chains concealing its face.

Wide-eyed freedom, may it return like a street girl. This will no longer be the freedom of old now that it has known Saint-Lazare. Its bruised fists ... how could you believe that one mental act alone could annihilate an idea? The word, though dishonoured on your public pediments, remained in your mouth when you were foolishly saying that it was banished from your heart. And thus denied, freedom finally *exists*. It emerges from the darkness, into which ceaseless causality flung it, adorned and enveloped by the concept of determination. Then who resolves the contradictions of freedom? Who is perfectly free and, at the same time, determined, necessary? Who draws from his necessity the principle of freedom? Such a being, who has no will but his becoming, who is subject to the development of the idea, and can only imagine, can only identify himself with the idea, surpasses his own self. He is the moral being, whom I conceive in extremes, who wants only what should be, and who, free in his existence, necessarily becomes the development of this free existence. Thus

freedom appears as the true foundation of morality, and its definition implies the very necessity of freedom. There can be no freedom in any act which turns against the idea of freedom. One is not free to act against it – that is, to act immorally.

Everything above implies a condemnation of metaphysical considerations in the field of sociology. This equanimity before contradictory ideas, which in politics passes for broad-mindedness and permits that continual reconciliation of irreconcilables by which social life is abusively perpetrated, is due only to a primary error concerning the range and significance of transcendental dialectics. Freedom for one is defined as freedom for all by this limitation, and this formula has made its way without anyone's dreaming of disputing its absurd terms. It is this false freedom to which our government *philosophers* refer. It is at the root of all Moderantism.

Oh moderates of all kinds, how can you cling to these vague morals, this morass in which you delight? I do not know which to admire more, your impartiality or your idiocy. Morality and freedom are in your vocabulary. But one would try in vain to get the definitions out of you. There is no morality but the morality of Terror, no freedom but the implacable ruling freedom: the world is like a woman in my arms. There will be fetters for the enemies of freedom. Man is free, but not men. There are no limits to freedom for one, there is no freedom for all. *All* is an empty notion, an awkward abstraction; one finally rediscovers his lost independence. Here ends the social history of humanity.

Fishers in troubled waters, your sophisms will not prevail: the movement of the mind is not indifferent, nor is it indifferently directed. There is a right and a left in the mind. And it is freedom that sends the needle of the compass towards this magnetic North, which is on the heart's side. Nothing, neither catastrophe nor people's mocking esteem, can thwart the fulfilment of becoming. The mind sweeps everything clean. In the centre of this great plain inhabited by man – where several suns were extinguished, one after the other, in the dried-up ponds that this great sky wind might rage – the idea above the fields arises and upsets everything. There is everything to gain from the greatest loss. The mind lives on disaster and death.

Those who die moderately for their fatherland . . . those who sleep moderately all day long . . . those who – and here indeed is your case, radicals – moderately restore deviations of opinion to simple powerless delinquencies, those masters of a polite and tolerant household, those moral dilettantes, those humbugs, those

sceptical jokers – will they be *our* masters for long, will they always practise oppression by smile? It is inconceivable that man's minor talents – for example, sociability – are exalted at the expense of his major talents, such as the capacity to kill. One twinge in the conscience of this tiger, who has been forced to take the annulated stripes of his coat for a prison, will suffice to make him rise to the moral notion of his freedom, when he will recognize the enemies of morality. Then, oh moderates, you will no longer be able to find refuge in the streets, in houses, in places of worship, in brothels, in children's innocence or in women's blue tears; then, owls and orators, tyrannical freedom will suddenly nail you to your doors, then it will cast its name to the universe with a great burst of laughter, and the universe will go on, saying that freedom is now called the Perpetual Revolution.

THE BUREAU OF SURREALIST ENQUIRIES

The few open invitations to the public to come and present itself at the Bureau of Enquiries have been extended. Indifference, which remains the most solid bulwark of the multitudes, is finally being overcome. Some critics, knowing nothing whatever of the question and obedient to the demands of their group, have attempted to be funny when confronted by the audacity of this manifestation; others, better informed, have been stirred; others have seen in it a real danger. For this reason certain critics have tried to make us a success simply as curiosities, but only a genuinely impoverished notion of our intentions can justify this attitude.

Nevertheless, the number of people we have welcomed grows from day to day, and although the interest of their progress varies, it is beginning to justify this hope that we place in *the unknown*, which each day must grant us a new revelation.

The Bureau of Surrealist Enquiries has been open since 11 October 1924 at 15 rue de Grenelle, Paris, from 4:30 to 6:30 every day except Sunday. Two people are in charge every day to assure its permanence. Several communications have been sent to the press on this subject, of which the following, reproduced here in part, retains all its present interest: 'The Bureau of Surrealist Enquiries is engaged in collecting, by every appropriate means, communications relative to the diverse forms which the unconscious activity of the mind is likely to take. No one area is specified *a priori* for this enterprise and surrealism proposes

to assemble the largest possible number of experimental data, to an end as yet unclear. Everyone who is prepared to contribute in any way to the creation of a real surrealist archive is urgently requested to make himself known: whether to enlighten us upon the genesis of an invention, to propose an unpublished system of psychic investigation, to allow us to judge striking coincidences, or to expound his most instinctive ideas on fashion as well as politics, etc.. . . . or he may wish to engage in a free criticism of morals, or finally, he may content himself with confiding his rarest dreams and what these dreams suggest to him.'

The Bureau of Enquiries must be above all a liaison agency. And that is certainly the direction its activity is taking. The curiosity about us experienced by a number of people must become a *real interest*, every visit made to us at the Bureau of Enquiries must display some genuinely new *asset*. Besides journalists, whose visits keep us in contact with a wide public, we have welcomed people with very different intentions, including several of whom knew almost nothing about surrealism. Let us encourage those who come to see us out of sympathy, but without announcing their complete adherence; if they were infinitely numerous there would be a still greater number of active individuals. Finally, we have become acquainted with some whose resolutions were extremely similar to our own; they are already at our side, acting . . .

Notice

With an eye to the most direct and effective action, it has been decided that on 20 January 1925 the Bureau of Surrealist Enquiries will be closed to the public. Work will go on, but differently. Beginning now, Antonin Artaud is assuming direction of the Bureau. A group of precise projects and manifestations being executed at present by the various committees will be published in Number Three of *La Révolution Surréaliste*.

The Central Bureau, more alive than ever, is henceforth behind sealed doors, but the world must know that it exists.

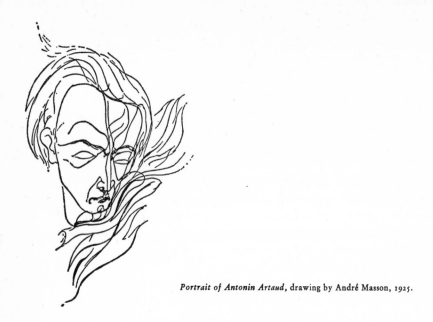

Portrait of Antonin Artaud, drawing by André Masson, 1925.

From *La Révolution Surréaliste,* No. 3, April 1925

DINNER IS SERVED

ANTONIN ARTAUD

Abandon the caverns of existence. Come, the spirit breathes outside the spirit. It is time to leave home. Surrender to Universal Thought. The Marvellous is at the root of the spirit.

We are within the spirit, inside the brain. Ideas, logic, order, Truth (with a capital T), reason: we sacrifice all to the void of death. Beware of your logic, Gentlemen, beware of your logic. You do not realize how far our hatred of logic can lead us.

Only by turning away from life, by checking the spirit, can the supposedly real physiognomy of life be determined, but reality is not to be found there. That is why we must not be annoyed in spirit, we who aspire to a certain surreal eternity and who for a long time now have not considered ourselves of the present, we who appear to ourselves as substantial phantoms.

Whoever judges us is not born to the spirit, to that spirit we have in mind which is for us outside what you call spirit. Our attention must not be too distracted by the chains attaching us to the spirit's petrifying imbecility. We have laid our hand on a new beast. The heavens respond to our attitude of wild absurdity. That trick you have of turning your back on questions will not prevent the heavens from opening up on the appointed day and establishing a new language from in the midst of your imbecile tracts. We mean the imbecile tracts of your ideas.

There are omens in Thought. Our attitude of absurdity and death is the most receptive. A wilfully sibylline world is speaking through the gaps in a henceforth unviable reality.

LETTER TO THE CHANCELLORS OF THE EUROPEAN UNIVERSITIES

Antonin Artaud

Gentlemen:

In the narrow tank which you call 'Thought' the rays of the spirit rot like old straw.

Enough plays on words, syntactic dodges, formula-juggling; now there is the great Law of the Heart to find, the Law which is not a Law (a prison) but a guide for the Spirit lost in its own labyrinth. Further away than science will ever reach, there where the arrows of reason break against the clouds, this labyrinth exists, a central point where all the forces of being and the ultimate nerves of Spirit converge. In this maze of moving and always changing walls, outside all known forms of thought, our Spirit stirs, watching for its most secret and spontaneous movements – those with the character of a revelation, an air of having come from elsewhere, of having fallen from the sky.

But the race of prophets is extinct. Europe crystallizes, slowly mummifies herself beneath the wrappings of her frontiers, her factories, her courts of justice, her universities. The frozen spirit cracks between the mineral staves which close upon it. The fault lies with your mouldy systems, your logic of two plus two equals four; the fault lies with you, Chancellors, caught in the net of syllogisms. You manufacture engineers, magistrates, doctors who do not know the true mystery of the body or the cosmic laws of existence; false scholars blind in the other world, philosophers who pretend to reconstruct the Spirit. The least

act of spontaneous creation is a more complex and revelatory world than any metaphysics.

So leave us alone, Gentlemen, you are only usurpers. By what right do you claim to canalize human intelligence and award spiritual certificates of merit?

You know nothing of the Spirit, you ignore its most secret and essential ramifications, those fossil imprints so close to our own origins, those tracts which occasionally we are able to discover deep in the most unexplored lodes of our minds.

In the name of your own logic we say to you: Life stinks, Gentlemen. Look at your faces for a moment, consider your products. Through the sieve of your diplomas is passing a whole generation of gaunt and bewildered youth. You are the plague of a world, Gentlemen, and so much the better for that world, but let it consider itself a little less at the head of humanity.

ADDRESS TO THE POPE

ANTONIN ARTAUD

You are not the confessional, O Pope, it is us, but comprehend us and may Catholicism comprehend us.

In the name of Family and Fatherland you urge the sale of souls, the unrestricted grindling of bodies.

Between our soul and ourselves we have enough paths to cross and enough distance that your tottering priests and that mass of adventurous doctrines which supports all the eunuchs of world liberalism are lost in the void.

As for your Catholic and Christian God who, like other gods, has conceived of all evil:

1. You are too strong for him.
2. We don't give a damn for your canons, index, sin, confessional, clergy, we are thinking of another war – war on you, Pope, dog.

Here spirit confesses to spirit.

From the heights of your Roman masquerade what triumph is hatred of the soul's immediate truths, of those flames which burn even the spirit? There is no God, Bible or Gospel, there are no words that impede the spirit.

We are not of the world, O Pope confined to the world, neither earth nor God speaks through you.

The world is the soul's abyss, warped Pope, Pope foreign to the soul. Let us swim in our own bodies, leave our souls within our souls; we have no need of your knife-blade of enlightenment.

ADDRESS TO THE DALAI LAMA

Antonin Artaud

We are your very faithful servants, O Great Lama. Grant to us, address to us your wisdoms, in a language which our contaminated European minds can understand, and if necessary change our Spirit, fashion for us a perception wholly attuned to those perfect summits where the Spirit of Man suffers no longer.

Make us a Spirit without habits, a perception truly frozen in the Spirit, or a Spirit with the purest habits, yours, if these are good for freedom.

We are surrounded by roughneck popes, scribblers, critics, dogs; our Spirit is among the dogs, whose thoughts are immediately earthbound, who think incorrigibly in the present.

Teach us, Lama, material levitation of the body and how we can be held no longer by the earth.

For you know well to what transparent liberation of souls we refer, to which freedom of Spirit in the Spirit, O acceptable Pope, O Pope of the true Spirit.

I behold you with the inner eye, O Pope, at the crest of the interior. It is inside that I resemble you, I, sprout, idea, lip, levitation, dream, cry, renunciation of idea, suspended among all forms and hoping only for the wind.

Moon over the Sea, colour lithograph by Max Ernst.

LETTER TO THE BUDDHIST SCHOOLS

ANTONIN ARTAUD

You who are not imprisoned in the flesh, who know at what point in its carnal trajectory, its senseless comings and goings, the soul finds the absolute verb, the new word, the inner land; you know how one turns back into one's thoughts, how the spirit can be saved from itself; you who are inside yourselves, whose spirit is no longer on the corporeal level, here are some hands for which *taking* is not everything, minds which see further than a forest of roofs, a flowering of façades, a nation of wheels, an activity of fire and marbles. This iron nation advances, words written with the speed of light advance, the sexes advance towards each other with the force of bullets. Yet what change will then be in the paths of the soul, in the spasms of the heart, in the frustrations of the spirit?

Therefore hurl into the ocean all these whites who arrive with their small heads and their well behaved minds. These curs must hear us. We do not speak of the old human ailment. Our spirit suffers from other needs than those inherent in life. We suffer from a corruption, the corruption of Reason.

Logical Europe endlessly crushes the mind between the jaws of two extremes: it opens and recloses the mind. But now the strangulation is at its peak. We have suffered too long under the yoke. The spirit is greater than the spirit, life's metamorphoses are manifold. Like you, we reject progress: come and tear down our houses.

Let our scribes continue to write for a while, our journalists to babble, our critics to blunder on, our Jews to slip into their patterns of plunder, our politicians to harangue, and our judicial assassins to brood over their crimes in peace. We know what life is. Our writers, our thinkers, our doctors, our dunces, are agreed to fail in life. Let all those scribes slander us, let them slander from spiritual castration, from the impossibility of attaining these lights and shades, these glazed clays, these revolving earths, where the lofty spirit of man is always changing. *We* have best captured thought. Come. Save us from these larvae. Devise for us new houses.

From *La Révolution Surréaliste*, No. 11, March 1928

THE QUINQUAGENARY OF HYSTERIA
(1878–1928)

Louis Aragon, André Breton

We surrealists are anxious to celebrate here the quinquagenary of hysteria, the greatest poetic discovery of the end of the nineteenth century, and to celebrate it at the very time when the dismemberment of the concept of hysteria would seem an accomplished fact. We who like nothing so much as youthful hysterics – the perfect example of which is furnished by observations relating to the delightful X. L. (Augustine), who entered the Salpétrière Asylum for Women during Dr Charcot's term on 21 October 1875, at the age of fifteen and a half years – how would we be affected by the laborious refutation of organic disorders, whose trials will never be that of hysteria except in the eyes of mere doctors? What a pity! M. Babinski, the most intelligent man who has attacked this problem, ventured to publish in 1913: 'When an emotion is sincere, profound and stirs the human soul, there is no room for hysteria.' One more reason for being better informed. Does Freud, who owes so much to Charcot, remember the time – confirmed by the survivors – when the interns at Salpétrière confused their professional duties and their taste for love, after nightfall, when the patients met them outside or received them in their beds? Afterwards those women patiently recounted, for the good of the medical cause which does not defend itself, their (supposedly pathological) mental attitudes under the influence of passion, which were so precious to them and are still precious to us as human beings. After fifty years, is the School of Nancy dead? If he is still alive, has Doctor Luys forgotten? But where are Neri's observations on the Messina earthquake? Where are the zouaves who were torpedoed by the Raymond Roussel of science, Clovis Vincent?

It is too easy to compare this 'complex and proteiform illness called hysteria which escapes all definition' (Bernheim) to the various definitions of hysteria which have been given up to this day – the hysteria divine in Antiquity, infernal in the Middle Ages, from the madmen of Loudun to the flagellants of Notre-Dame des Pleurs (Long live Madame Chantelouve!) – mythical, erotic, or simply lyrical definitions, social definitions, scholarly definitions. Those who have seen

the very beautiful film 'Sorcery Through the Ages' certainly recall having found, on the screen or in the house, lessons more vivid than those in books by Hippocrates or Plato, where the uterus capers like a little goat, or by Galen who immobilizes the goat, or by Fernel, who got it on the march again in the sixteenth century and saw it re-ascend to the stomach under his power; they saw the horns of the beast grow and grow until they became those of the devil. The devil, in turn, defaulted. Positivist hypotheses divide his estate. The crisis of hysteria takes form at the expense of hysteria itself, with its superb aura, its four periods, the third of which engages us as much as the purest and most expressive *tableaux vivants*, and its very simple resolution in normal life. Classic hysteria was deprived of its features in 1906: 'Hysteria is a pathological condition manifested by disorders which can be reproduced in certain subjects with complete exactitude by suggestion, and which are likely to disappear under the influence of persuasion (counter-suggestion) alone' (Babinski).

We see in this definition only one moment in the evolution of hysteria. The dialectic movement which gave it life follows its course. Ten years later, under the deplorable disguise of '*pithiatisme*', hysteria is beginning to regain its rights. Doctors are amazed. They want to deny what does not belong to them.

Thus, in 1928, we propose a new definition of hysteria:

Hysteria is a more or less irreducible mental condition characterized by the subversion of the relations which are established between the subject and the moral world with which he believes himself able to cope, outside every delirious system. This mental condition is based upon the need for a mutual enticement, which explains the prematurely accepted miracles of medical suggestion (or counter-suggestion). Hysteria is not a pathological phenomenon and can be considered in every respect a supreme means of expression.

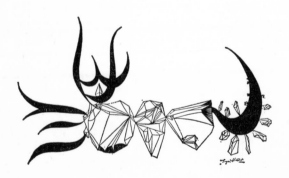

India ink drawing by Jacques Hérold.

From *La Révolution Surréaliste*, No. 12, December 1929
(First appeared in *Littérature*, Dec. 1920.)

FROM AN ARTICLE BY JACQUES RIGAUT

I haven't taken much seriously: as a child I stuck out my tongue at the poor women who accosted my mother in the street to ask for alms and on the sly I pinched their brats, who were already weeping from the cold; when my dying father wanted to confide his last wishes to me and called me close to his bed, I seized the maid, singing 'Your parents will have to be tricked – you'll see why it's you to love I picked' ... Wherever I could betray a friend's confidence, I don't think I missed the chance. But there is little merit in jeering at kindness or ridiculing charity, and the surest way of having some comic relief is to deprive creatures of their little lives – without any motive, just for laughs. Children don't deceive themselves, they know how to enjoy the pleasure of throwing an ant hill into panic or squashing two flies surprised in the act of copulation. During the war I threw a grenade into a shelter where two comrades were getting ready to go on leave. What a peal of laughter at my mistress's terrified face when, as she waited to receive a caress, I slugged her with my American right hook and her body fell several feet away; and what a sight, those people who struggled to get out of the Gaumont-Palace after I had set fire to it!

But tonight you have nothing to fear, I have taken it into my head to be serious. Obviously there isn't a word of truth in the preceding tales – I am the best-behaved little boy in Paris – but so often I have delighted in imagining that I had accomplished or was going to accomplish such honourable exploits that it isn't completely a lie either. And, anyway, I have scoffed at quite a few things! Only one thing in the world I have never succeeded in scoffing at: pleasure. If I were still capable of shame or self-respect, you can well believe that I would not be able to bring myself to such a painful confidence. Another day I will explain to you why I never lie: one has nothing to hide from one's servants. But let us return to pleasure, which promises to overtake you and, with two little notes of music, win you over to the idea of skin, and many other ideas as well. As long as I do not overcome the taste for pleasure, I well know that I shall be susceptible to the intoxication of suicide.

The first time I killed myself it was to annoy my mistress. That virtuous creature brusquely refused to sleep with me, saying that she was overcome by remorse

for betraying her first-string lover. I do not really know if I loved her – I suspect that a fortnight away from her would have singularly diminished my need for her – but her refusal exasperated me. How to reach her? Have I said that she retained a deep and lasting tenderness for me? I killed myself to annoy my mistress. I am forgiven this suicide in consideration of my extreme youth at the time.

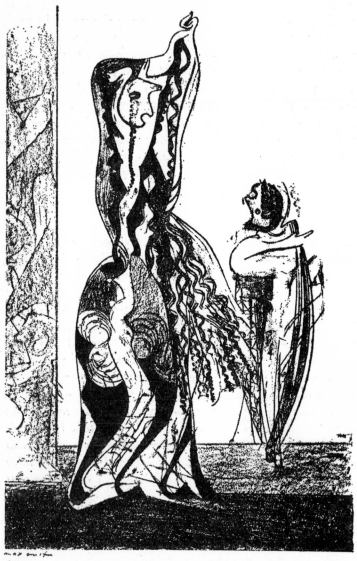

The Dancer,
lithograph
by Max Ernst.

trait of Yves Tanguy by Man Ray, 1936

36 Jacques Prévert, 1922

cel Duhamel, 1927

38 André Masson, 1958

39 Georges Malkine, 1929

40 Salvador Dali, 1929

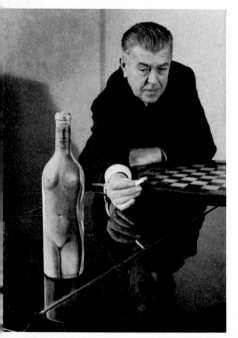

41 René Magritte, 1960

42 René Char, 1935

a and Salvador Dali with an 'object' by Man Ray, 1936

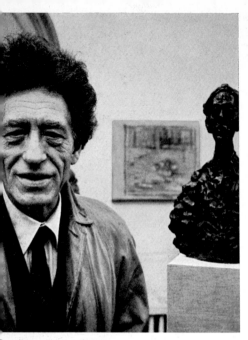

Alberto Giacometti, 1963

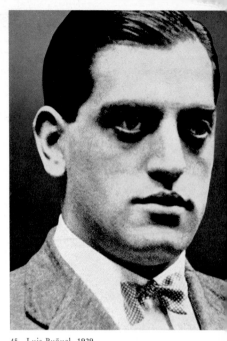

45 Luis Buñuel, 1929

6 Joseph Šima, 1963

47 Jacques Hérold as a torero, 1941

55 Toyen, 1956 56 Richard Oelze, 1962

ists in exile, New York, February 1942. Back row, left to right: André Breton, Piet Mondrian, André Masson, Amé-
Ozenfant, Jacques Lipchitz, Pavlik Chelichev, Kurt Seligman, Eugène Berman. Front row, left to right: Matta, Ossip
kine, Yves Tanguy, Max Ernst, Marc Chagall, Fernand Léger

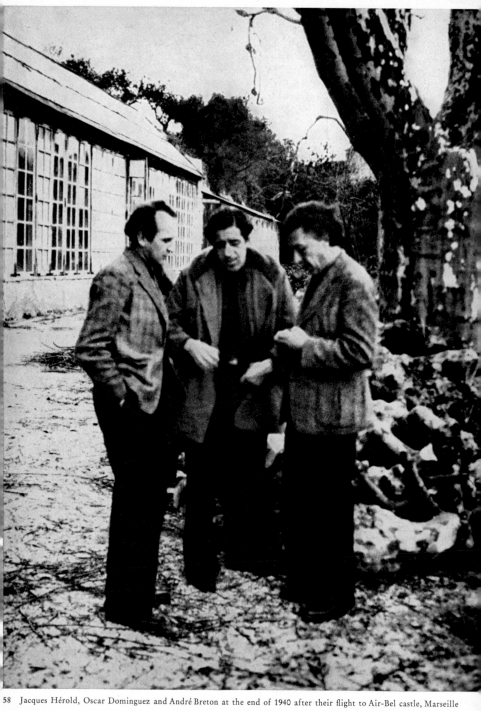

58 Jacques Hérold, Oscar Dominguez and André Breton at the end of 1940 after their flight to Air-Bel castle, Marseille

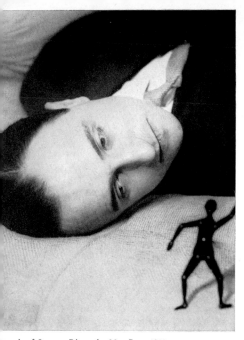

rtrait of Jacques Rigaut by Man Ray, 1922

60 Portrait of René Crevel by Man Ray, 1929

tonin Artaud in 1948, a year before his death

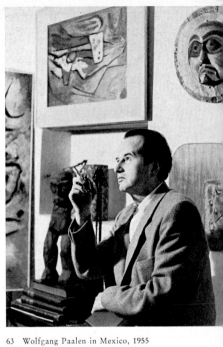

2 Jean-Pierre Duprey, 1956

63 Wolfgang Paalen in Mexico, 1955

64 Oscar Dominguez, 1957

65 Robert Desnos, 1922

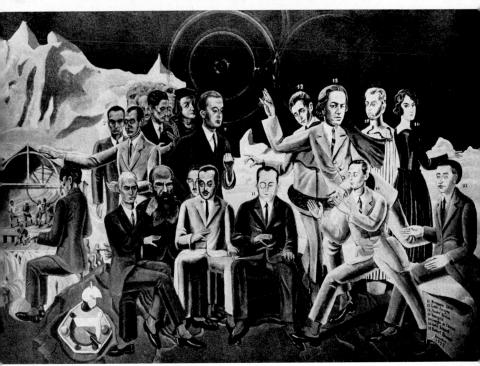

Max Ernst *At the Rendezvous of Friends,* December, 1922. 1 René Crevel, 2 Philippe Soupault, 3 Jean Arp, 4 Max Ernst, 5 Max Morise, 6 Fyodor Dostoevsky, 7 Rafael Sanzio, 8 Théodore Fraenkel, 9 Paul Eluard, 10 Jean Paulhan, 11 Benjamin Péret, 12 Louis Aragon, 13 André Breton, 14 Baargeld, 15 Giorgio de Chirico, 16 Gala Eluard, 17 Robert Desnos

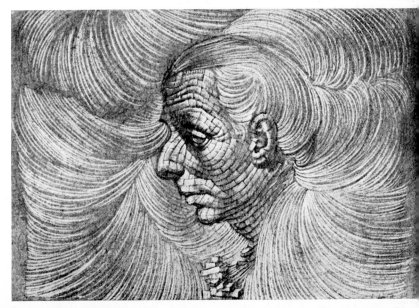

67 Hans Bellmer *Portrait of Max Ernst,* 1938

68 Léonor Fini in Corsica, 1959

69 Léonor Fini *The End of the World*, 1944

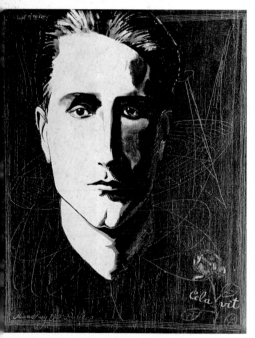

70 Man Ray *Portrait of Marcel Duchamp*, 1923

71 Hans Bellmer *Portrait of Tristan Tzara*, 1954

stellation, 1935, by Valentine Hugo shows six surrealist 'stars': Paul Eluard, André Breton, Tristan Tzara, Benjamin
et, René Crevel, René Char

3 Portrait of Meret Oppenheim by Man Ray, 1933

4 Portrait of Dora Maar by Man Ray, 1936

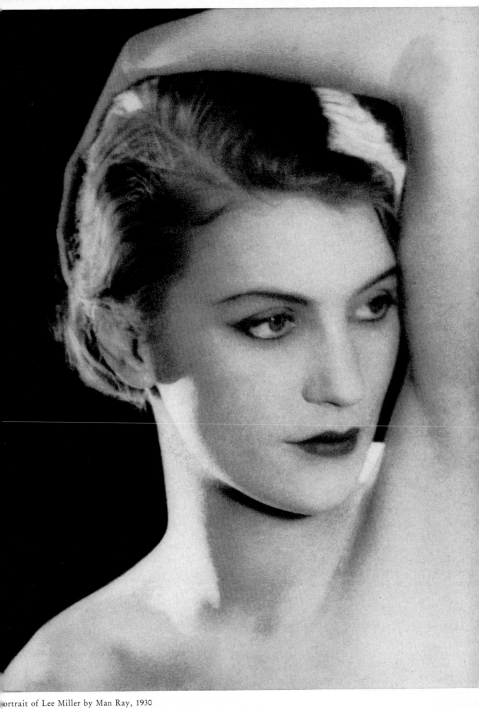

ortrait of Lee Miller by Man Ray, 1930

Pablo Picasso *Nude Woman Reclining*, 1936

Max Ernst *Petrified Forest*, 1926

The second time I killed myself it was from laziness. Poor, and having an anticipatory horror of all work, one day I killed myself as I had lived – without conviction. They do not hold this death against me when they see how blooming I am today.

The third time – I will spare you the recital of my other suicides provided you will consent to listen to this one more – I had just gone to bed after an evening during which my boredom had been no more overwhelming than on other nights. I remember very clearly that I made the decision and, at the same time, pronounced the sole reason. And then *zut!* I got up and went to look for the only weapon in the house, a little revolver which one of my grandfathers had bought and which was loaded with bullets as old as the gun. (You will see in a moment why I stress this detail.) I lay down naked on my bed. It was cold, so I hastened to bury myself under the covers. I cocked the hammer. I felt the cold steel in my mouth. At that moment it is likely that I also felt my heart beating, just as I felt it beating when listening to a shell before it exploded – in the presence of something irrevocable but unconsummated. I pressed the trigger, the hammer clicked, but the shot didn't go off. I then laid my weapon on a small table, probably laughing a little nervously. Ten minutes later, I was asleep ... I think that I just made a slightly important remark, but ... of course! ... It goes without saying that I did not for a moment dream of firing another shot. The important thing was that I had made the decision to die, not whether I actually died.

A man spared by bores and boredom perhaps finds in suicide the accomplishment of the most unselfish gesture, provided that he is not curious about death! I have absolutely no idea when and how I could have thought that way, which in any case hardly troubles me. But there, all the same, is the most absurd act, fantasy at its explosion, and unconstraint beyond sleep and purest compromise.

[*Note:* Jacques Rigaut killed himself with a revolver shot in the heart on 5 November 1929.]

First Surrealist Manifesto

From *Le Manifeste du Surréalisme,* 1924

We are still living under the reign of logic, but the logical processes of our time apply only to the solution of problems of secondary interest. The absolute rationalism which remains in fashion allows for the consideration of only those facts narrowly relevant to our experience. Logical conclusions, on the other hand, escape us. Needless to say, boundaries have been assigned even to experience. It revolves in a cage from which release is becoming increasingly difficult. It too depends upon immediate utility and is guarded by common sense. In the guise of civilization, under the pretext of progress, we have succeeded in dismissing from our minds anything that, rightly or wrongly, could be regarded as superstition or myth; and we have proscribed every way of seeking the truth which does not conform to convention. It would appear that it is by sheer chance that an aspect of intellectual life – and by far the most important in my opinion – about which no one was supposed to be concerned any longer has, recently, been brought back to light. Credit for this must go to Freud. On the evidence of his discoveries a current of opinion is at last developing which will enable the explorer of the human mind to extend his investigations, since he will be empowered to deal with more than merely summary realities. Perhaps the imagination is on the verge of recovering its rights. If the depths of our minds conceal strange forces capable of augmenting or conquering those on the surface, it is in our greatest interest to capture them; first to capture them and later to submit them, should the occasion arise, to the control of reason. The analysts themselves can only gain by this. But it is important to note that there is no method fixed *a priori* for the execution of this enterprise, that until the new order it can be considered the province of poets as well as scholars, and that its success does not depend upon the more or less capricious routes which will be followed.

It was only fitting that Freud should appear with his critique on the dream. In fact, it is incredible that this important part of psychic activity has still attracted so little attention. (For, at least from man's birth to his death, thought presents no solution of continuity; the sum of dreaming moments – even taking into consideration pure dream alone, that of sleep – is from the point of view of time no less than the sum of moments of reality, which we shall confine to waking moments.) I have always been astounded by the extreme disproportion in the importance and seriousness assigned to events of the waking moments and to those of sleep by the ordinary observer. Man, when he ceases to sleep, is above all at the mercy of his memory, and the memory normally delights in feebly retracing the circumstance of the dream for him, depriving it of all actual consequence and obliterating the only *determinant* from the point at which he thinks he abandoned this constant hope, this anxiety, a few hours earlier. He has the illusion of continuing something worthwhile. The dream finds itself relegated to a parenthesis, like the night. And in general it gives no more counsel than the night. This singular state of affairs seems to invite a few reflections:

1 Within the limits to which its performance is restricted (or what passes for performance), the dream, according to all outward appearances, is continuous and bears traces of organization. Only memory claims the right to edit it, to suppress transitions and present us with a series of dreams rather than *the dream.* Similarly, at no given instant do we have more than a distinct representation of realities whose co-ordination is a matter of will.[1] It is important to note that nothing leads to a greater dissipation of the constituent elements of the dream. I regret discussing this according to a formula which in principle excludes the dream. For how long, sleeping logicians, philosophers? I would like to sleep in order to enable myself to surrender to sleepers, as I surrender to those who read me with their eyes open, in order to stop the conscious rhythm of my thought from prevailing over this material. Perhaps my dream of last night was a continuation of the preceding night's, and will be continued tonight with an admirable precision. *It could be,* as they say. And as it is in no way proven that, in such a case, the 'reality' with which I am concerned even exists in the dream state, or that it does not sink into the immemorial, then why should I not concede to the dream what I sometimes refuse to reality – that weight of self-assurance which by its own terms is not exposed to my denial? Why should I not expect more of the dream sign than I do of a daily increasing degree of consciousness? Could not the dreams as well be applied to the solution of life's fundamental problems? Are these problems the same in one case as in the other,

and do they already exist in the dream? Is the dream less oppressed by sanctions than the rest? I am growing old and, perhaps more than this reality to which I believe myself confined, it is the dream, and the detachment that I owe to it, which is ageing me.

2 I return to the waking state. I am obliged to retain it as a phenomenon of interference. Not only does the mind show a strange tendency to disorientation under these conditions (this is the clue to slips of the tongue and lapses of all kinds whose secret is just beginning to be surrendered to us), but when functioning normally the mind still seems to obey none other than those suggestions which rise from that deep night I am commending. Sound as it may be, its equilibrium is relative. The mind hardly dares express itself and, when it does, is limited to stating that this idea or that woman *has an effect on it*. What effect it cannot say; thus it gives the measure of its subjectivism and nothing more. The idea, the woman, *disturbs* it, disposes it to less severity. Their role is to isolate one second of its disappearance and remove it to the sky in that glorious acceleration that it can be, that it is. Then, as a last resort, the mind invokes chance – a more obscure divinity than the others – to whom it attributes all its aberrations. Who says that the angle from which that idea is presented which affects the mind, as well as what the mind loves in that woman's eye, is not *precisely* the same thing that attracts the mind to its dream and reunites it with data lost through its own error? And if things were otherwise, of what might the mind not be capable? I should like to present it with the key to that passage.

3 The mind of the dreaming man is fully satisfied with whatever happens to it. The agonizing question of possibility does not arise. Kill, plunder more quickly, love as much as you wish. And if you die, are you not sure of being roused from the dead? Let yourself be led. Events will not tolerate deferment. You have no name. Everything is inestimably easy.

What power, I wonder, what power so much more generous than others confers this natural aspect upon the dream and makes me welcome unreservedly a throng of episodes whose strangeness would overwhelm me if they were happening as I write this? And yet I can believe it with my own eyes, my own ears. That great day has come, that beast has spoken.

If man's awakening is harsher, if he breaks the spell too well, it is because he has been led to form a poor idea of expiation.

4 When the time comes when we can submit the dream to a methodical examination, when by methods yet to be determined we succeed in realizing the dream in its entirety (and that implies a memory discipline measurable in

André Masson, *Automatic sketch*, 1925/26.

generations, but we can still begin by recording salient facts), when the dream's curve is developed with an unequalled breadth and regularity, then we can hope that mysteries which are not really mysteries will give way to the great Mystery. I believe in the future resolution of these two states – outwardly so contradictory – which are dream and reality, into a sort of absolute reality, a *surreality*, so to speak. I am aiming for its conquest, certain that I myself shall not attain it, but too indifferent to my death not to calculate the joys of such possession.

They say that not long ago, just before he went to sleep, Saint-Pol-Roux placed a placard on the door of his manor at Camaret which read: THE POET WORKS.

There is still a great deal to say, but I did want to touch lightly, in passing, upon a subject which in itself would require a very long exposition with a different precision. I shall return to it. For the time being my intention has been to see that justice was done to that *hatred of the marvellous* which rages in certain men, that ridicule under which they would like to crush it. Let us resolve, therefore: the Marvellous is always beautiful, everything marvellous is beautiful. Nothing but the Marvellous is beautiful.

... One night, before falling asleep, I became aware of a most bizarre sentence, clearly articulated to the point where it was impossible to change a word of it, but still separate from the sound of any voice. It came to me bearing no trace of the events with which I was involved at that time, at least to my conscious knowledge. It seemed to me a highly insistent sentence – a sentence, I might say, *which knocked at the window*. I quickly took note of it and was prepared to disregard it when something about its whole character held me back. The sentence truly astounded me. Unfortunately I still cannot remember the exact words to this day, but it was something like: 'A man is cut in half by the window'; but it can only suffer from ambiguity, accompanied as it was by the feeble visual representation of a walking man cut in half by a window perpendicular to the axis of his body.[2] It was probably a simple matter of a man leaning on the window and then straightening up. But the window followed the movements of the man, and I realized that I was dealing with a very rare type of image. Immediately I had the idea of incorporating it into my poetic material, but no sooner had I invested it with poetic form than it went on to give way to a scarcely intermittent succession of sentences which surprised me no less than the first and gave me the impression of such a free gift that the control which I had had over myself up to that point seemed illusory and I no longer thought of anything but how to put an end to the interminable quarrel which was taking place within me.[3]

Totally involved as I was at the time with Freud, and familiar with his methods of examination which I had had some occasion to practise on the sick during the war, I resolved to obtain from myself what one seeks to obtain from a patient – a spoken monologue uttered as rapidly as possible, over which the critical faculty of the subject has no control, unencumbered by any reticence, which is *spoken thought* as far as such a thing is possible. It seemed to me, and still does – the manner in which the sentence about the man cut in two came to me proves it – that the speed of thought is no greater than that of words, and that it does not necessarily defy language or the moving pen. It was with this in mind that Philippe Soupault (with whom I had shared these first conclusions) and I undertook to cover some paper with writing, with a laudable contempt for what might result in terms of literature. The ease of realization did the rest. At the end of the first day we were able to read to each other around fifty pages obtained by this method, and began to compare our results. Altogether, those of Soupault and my own presented a remarkable similarity, even including the same faults in construction: in both cases there was the illusion of an extraordinary verve, a great deal of emotion, a considerable assortment of images of a quality such as we would never have been capable of achieving in ordinary writing, a very vivid graphic quality, and here and there an acutely comic passage. The only difference between our texts seemed to me essentially due to our respective natures (Soupault's is less static than mine) and, if I may hazard a slight criticism, due to the fact that he had made the mistake of distributing a few words in the way of titles at the head of certain pages – no doubt in the spirit of mystification. On the other hand, I must give him credit for maintaining his steadfast opposition to the slightest alteration in the course of any passage which seemed to me rather badly put. He was completely right on this point, of course.[4] In fact it is very difficult to appreciate the full value of the various elements when confronted by them. It can even be said to be impossible to appreciate them at the first reading. These elements are outwardly *as strange to you who have written them as to anyone else*, and you are naturally distrustful of them. Poetically speaking, they are especially endowed with a very high degree of *immediate absurdity*. The peculiarity of this absurdity, on closer examination, comes from their capitulation to everything – both inadmissible and legitimate – in the world, to produce a revelation of a certain number of premises and facts generally no less objective than any others.

In homage to Guillaume Apollinaire – who died recently, and who appears to have consistently obeyed a similar impulse to ours without ever really sacrificing mediocre literary means – Soupault and I used the name SUR-

REALISM to designate the new mode of pure expression which we had at our disposal and with which we were anxious to benefit our friends. Today I do not believe anything more need be said about this word. The meaning which we have given it has generally prevailed over Apollinaire's meaning. With even more justification we could have used SUPERNATURALISM, employed by Gerard de Nerval in the dedication of *Filles de Feu*.[5] In fact, Nerval appears to have possessed to an admirable extent the *spirit* to which we refer. Apollinaire, on the other hand, possessed only the *letter* of surrealism (which was still imperfect) and showed himself powerless to give it the theoretical insight that engages us. Here are two passages by Nerval which appear most significant in this regard:

'I will explain to you, my dear Dumas, the phenomenon of which you spoke above. As you know, there are certain story-tellers who cannot invent without identifying themselves with the characters from their imagination. You know with what conviction our old friend Nodier told how he had had the misfortune to be guillotined at the time of the Revolution; one became so convinced that one wondered how he had managed to stick his head back on.'

'... And since you have had the imprudence to cite one of the sonnets composed in this state of SUPERNATURALIST reverie, as the Germans would say, you must hear all of them. You will find them at the end of the volume. They are hardly more obscure than Hegel's metaphysics or Swedenborg's MEMORABLES, and would lose their charm in explication, if such a thing were possible, so concede me at least the merit of their expression ...'[6]

It would be dishonest to dispute our right to employ the word SURREALISM in the very particular sense in which we intend it, for it is clear that before we came along this word amounted to nothing. Thus I shall define it once and for all:

SURREALISM, noun, masc., Pure psychic automatism by which it is intended to express, either verbally or in writing, the true function of thought. Thought dictated in the absence of all control exerted by reason, and outside all aesthetic or moral preoccupations.

ENCYCL. *Philos.* Surrealism is based on the belief in the superior reality of certain forms of association heretofore neglected, in the omnipotence of the dream, and in the disinterested play of thought. It leads to the permanent destruction of all other psychic mechanisms and to its substitution for them in the solution of the principal problems of life.

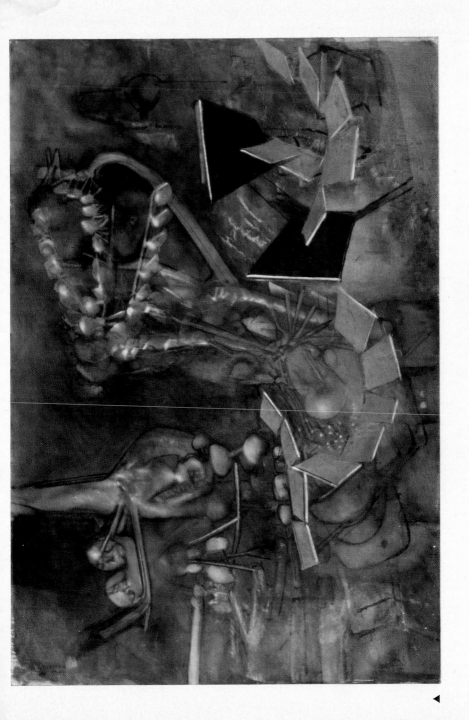

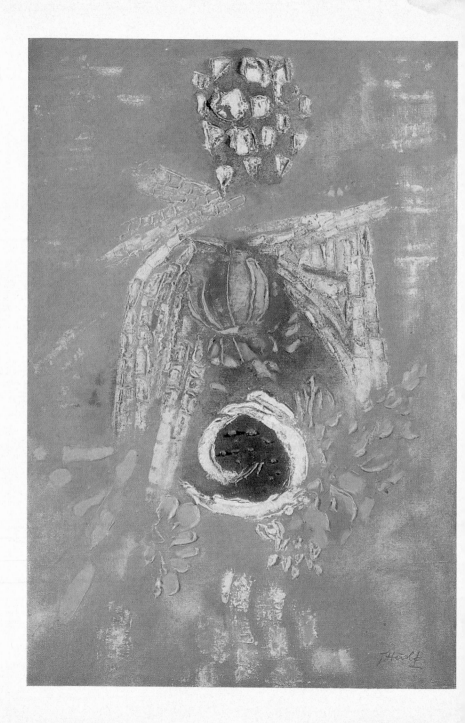

9.quilles

ONDÉE

TOYEN

Drawing by Toyen for
Néon, No. 1, 1948.

Secrets of the Art of Surrealist Magic

Surrealist Written Composition, or First and Last Drafts

Supply yourself with writing materials, after having settled yourself in a place as favourable as possible to the mind's concentration on itself. Attain the most passive or receptive state of mind possible. Forget your genius, your talents, and those of everyone else. Tell yourself firmly that literature is one of the unhappiest routes leading to everything. Write quickly with no preconceived subject, so quickly that you retain nothing and are not tempted to re-read. The first sentence will come by itself, since it is true that each second there exists a sentence foreign to our conscious thoughts which asks only to be brought out in to the open. It is somewhat difficult to make a definite statement about the next sentence; no doubt it partakes of our conscious and unconscious activities at the same time, if one admits that the fact of having written the first sentence implies a minimum of perception. Besides, it should matter little to you. Here lies the greatest interest of the surrealist game. Unquestionably, punctuation

always opposes the absolute continuity of the flow which occupies us, although
it seems as necessary as the distribution of knots in a vibrating rope. Continue
as long as you please. Trust in the inexhaustible spirit of the whisper. If silence
threatens in the least to establish itself you have made a mistake – a mistake
shall we say, of inattention. Make a break at the too-intelligible line
immediately. After the word whose origin seems suspect place any letter, the
letter *l* for example, always the letter *l*, and restore the arbitrary by making
this letter the initial of the next word.

How Not to Be Bored in Company Any More

This is very difficult. Do not be at home to anyone, but now and then when
'anyone' disregards your orders, interrupting you in the middle of surrealist
activity and just standing there, say: 'Never mind, no doubt it is all for the best
to be done or not to be done. The interest of life is not sustained. Simplicity,
what is happening within me is still a nuisance!' or some other revolting
banality.

How to Make Speeches

Have yourself registered on the eve of elections in the first country that will
agree to proceed with this type of lecture. Every man has in him the making
of an orator: the coloured loin-cloths and glass necklaces of words. In
surrealism he will surprise despair in its poverty. One night on a platform,
singlehanded, he will dismember the eternal heavens, those unhatched chicken.
He will promise as well as perform so little that it will be astounding. He will
answer the demands of an entire nation with a partial and derisive evasion.
He will reconcile the most irreconcilable adversaries in a secret desire which
will explode the fatherlands. And in so doing he will succeed in rising above the
boundless oratory which is grounded in piety and rolls in hatred. Incapable of
failure, he will gamble on the weakness of all failures. He will certainly be
elected and the gentlest women will love him violently.

How to Write False Novels

Whoever you are, if you feel like it, you will burn a few laurel leaves and
without bothering to maintain this pathetic fire you will begin to write a novel.
Surrealism will permit you; you have only to set the 'No Obstacles' pointer to

'Action' and the journey has begun. Here are some rather dissimilar characters; their names in your handwriting are a question of capital letters and they will behave with the same ease towards active verbs as the impersonal pronoun *it* towards words like *rains, is, must be,* etc. They will control them, as it were, and where observation, reflection and the ability to generalize have been no help to you, rest assured that these characters will lend you a thousand intentions you never had. Thus provided with a small number of physical and moral characteristics, these beings who in truth owe you so little will no longer swerve from a certain line of conduct to which you need only apply yourself. There will result an intrigue more or less expert in appearance, justifying point by point that stirring or reassuring *dénouement* to which you pay no attention. Your false novel will simulate a real novel to perfection. You will be rich and it will be agreed that you 'have guts', and all the more so since that is where your talent remains.

How to Appear in a Good Light to a Woman Passing in the Street

Against Death

Surrealism will introduce you to death, which is a secret society. It will glove your hand, entombing there the consummate M with which the word Memory begins. Do not fail to make auspicious testamentary arrangements; for my part, I ask to be driven to the cemetery in a moving van. Let my friends destroy every copy of the edition of the *Discourse on the Worthlessness of Reality*.

Second Surrealist Manifesto

From *Le Second Manifeste du Surréalisme,* 1929*

ANDRÉ BRETON

In spite of the individual courses peculiar to each of its past and present participants, in the end surrealism's overall tendency will be readily admitted to have been nothing so much as the provocation, from an intellectual and moral point of view, of the most universal and serious kind of *crisis of conscience,* and it will be agreed that the attainment or non-attainment of this result can decide its historical success or defeat.

From an intellectual point of view, it was and still is necessary to expose by every available means the factitious character of the old contradictions hypocritically calculated to hinder every unusual agitation on the part of man, and to force its recognition at all costs, if only to give mankind some faint idea of its abilities and to challenge it to escape its universal shackles to some meaningful extent. The bugbear of death, the music-halls of the beyond, the shipwreck of the loftiest intellect in sleep, the crushing curtain of the future, the towers of Babel, the mirrors of inconsistency, the insurmountable silver-splashed wall of the brain – all of these striking images of human catastrophe are perhaps nothing but images. There is every reason to believe that there exists a certain point in the mind at which life and death, real and imaginary, past and future, communicable and incommunicable, high and low, cease to be perceived in terms of contradiction. Surrealist activity would be searched in vain for a motive other than the hope to determine this point. Thus it is sufficiently obvious that it would be absurd to attribute to that activity a uniquely de-structive, or constructive, direction: the point in question is, *a fortiori,* that con-struction and destruction can no longer be brandished against each other. It is also clear that surrealism is not interested in taking much account of what is produced peripherally under the pretext of art – which is really anti-art – philosophy or anti-philosophy, in short, everything that does not conclude in

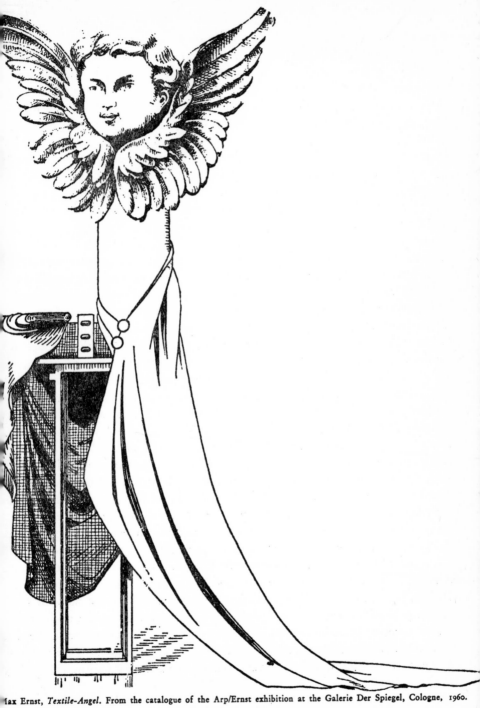

Max Ernst, *Textile-Angel*. From the catalogue of the Arp/Ernst exhibition at the Galerie Der Spiegel, Cologne, 1960.

the annihilation of being into a blind, inner splendour which would be no more the essence of ice than of fire. What indeed could be expected from the surrealist experience by those who retain some anxiety about the place they will occupy *in the world?* On that mental plane from which one can undertake for oneself alone the perilous – but, we believe, supreme – recognition, there can be no question of attaching the least importance to the footsteps of those who come or go, since these footsteps occur in a region where, by definition, surrealism has no ear. Surrealism should not be at the mercy of this or that man's whim; if it declares that it can, by its own means, deliver thought from an ever harsher bondage, put it back on the path of total understanding, restore its original purity, then that is enough to justify its being judged only by what it has done and by what remains to be done in order to keep its promise.

Surrealism, particularly in regard to its means of undertaking the investigation of the elements of reality and unreality, reason and unreason, reflection and impulse, knowledge and 'fatal' ignorance, utility and inutility, etc., presents at least one analogy with historical materialism in that it departs from the 'colossal abortion' of the Hegelian system. It seems impossible to me that limits can be assigned – those of the economic plan, for example – to the practice of a philosophy definitely adaptable to negation and the negation of negation. How can they acknowledge that the dialectic method can only be validly applied to the solution of social problems? Surrealism's whole ambition is to furnish that method with possibilities of application not at all concurrent in the most immediate realms of consciousness. With all due respect to certain narrow-minded revolutionaries, I really do not see why we should abstain from raising problems of love, dream, madness, art and religion, [1] provided that we consider them in the same light in which they, and we too, consider Revolution. And I do not hesitate to say that before surrealism nothing systematic had been done in this direction, and that when we found it, *the dialectic method was* – for us too – *inapplicable in its Hegelian form.* For us too it was a question of the need to have done with idealism as such (the creation of the word surrealism alone should prove that) and to return to Engels's example of the need to stop clinging to the juvenile development: 'The rose is a rose. The rose is not a rose. But the rose is still a rose.' Nevertheless – forgive me this digression – it was necessary to set 'the rose' into action conducive to less favourable contradictions, where it might be in succession something from the garden, something with a particular role in a dream, something impossible to separate from the 'optical bouquet', something which can totally change its nature by passing into auto-

matic writing, something which has none of the rose's properties except those the painter has decided to retain in a surrealist painting, and finally, something entirely different from itself, which returns to the garden. This is a far cry from any idealistic conception, and we would not even mention it if we might stop being continuously exposed to attacks of elementary materialism, attacks which emanate both from those who, out of decadent conservatism, have no desire to clarify the relation of thought to matter, and from those who, out of a misunderstood revolutionary sectarianism and in defiance of what is needed, confuse this materialism with that which Engels essentially distinguished from it and which he defined as above all an *intuition of the world* called upon to prove and fulfil itself: *In the course of the development of philosophy, idealism became untenable and was denied by modern materialism. The latter, which is the negation of negation, is not simply a restoration of the old materialism: to those solid foundations it adds the entire conception of philosophy and the natural sciences in the course of a two-thousand-year evolution as well as the product of this long history itself.* We also intend to make it understood as a point of departure that for us philosophy is *outclassed*. This is the fate, I think, of all those for whom reality has not only a theoretical importance but for whom it is also a question of life and death to appeal passionately to that reality, as Feuerbach insisted: ours to give as we *totally*, unreservedly give our support to the principle of historical materialism, his to throw in the face of the astounded intellectual world the idea that 'man is what he eats' and that a future revolution would have a better chance of success if the people received better food, such as peas instead of potatoes.

Our support of the principal of historical materialism – there is no way of playing on these words. Let that depend only on us – I mean provided communism does not treat us merely as strange animals determined to practise star-gazing and defiance in its ranks – and we shall show ourselves capable of doing our full duty from a revolutionary point of view. This, unfortunately, is a pledge which interests only us: for example, two years ago I myself could not enter, freely and unobserved, the headquarters of the French Party, where nevertheless so many disreputable individuals – police and others – are allowed to carry on as though they were in a boiler factory. In the course of three interrogations of several hours' length, I had to defend surrealism against the childish accusation of being in essence a political movement with a clearly anti-communist and counter-revolutionary bent. Needless to say, I expected nothing from the thorough investigation of my ideas on the part of those who were judging me. 'If you are a Marxist', Michel Marty shouted at one of us around

that time, 'you do not need to be a surrealist.' Surrealists that we were, it was of course not we who boasted of it in those circumstances: this label had preceded us in spite of ourselves just as that of 'relativists' might have preceded the followers of Einstein, or 'psychoanalysts' those of Freud. How can one not be terribly worried about such a weakening of the ideological level of a party which not long before had emerged so brilliantly armed with two of the best minds of the nineteenth century! One hardly knows: the little that I can conclude from my own personal experience in this regard can be measured by the following. They asked me to give a report on the Italian situation in the 'Gas' cell, specifying that I was to rely upon statistical facts alone (steel production, etc.) and *especially no ideology*. I could not.

78 Max Ernst *After Me, Sleep (The Grave of the Poet Paul Eluard)*, 1958

79 Max Ernst *Spring in Paris*, 1950

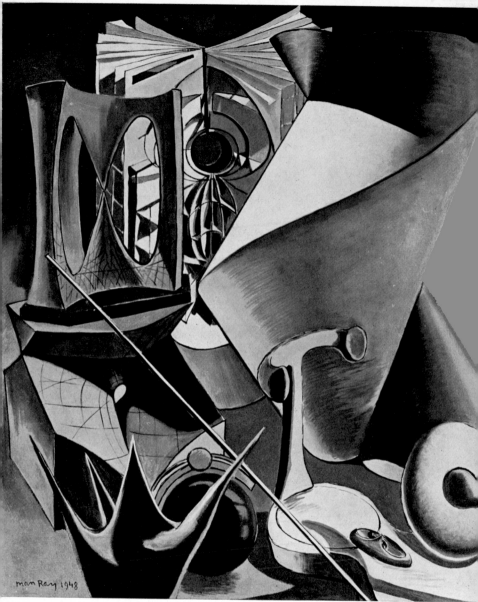

80 Man Ray *Shakespearian Equation: 'Twelfth Night'*, 1948

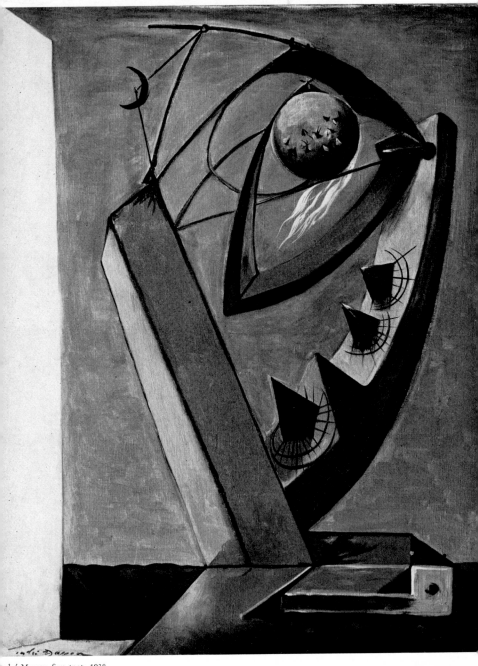

ndré Masson *Sun-trap*, 1938

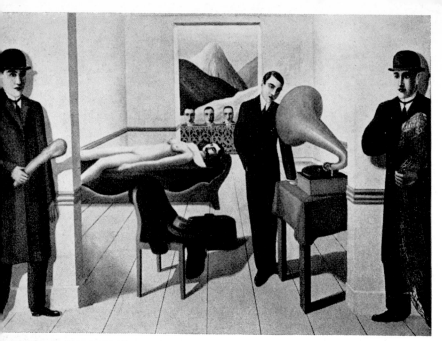

René Magritte *The Assassin Threatened*, 1926

3 Yves Tanguy *Et voilà!*, 1927

84 Joan Miró *Portrait of Mme K*, 1924

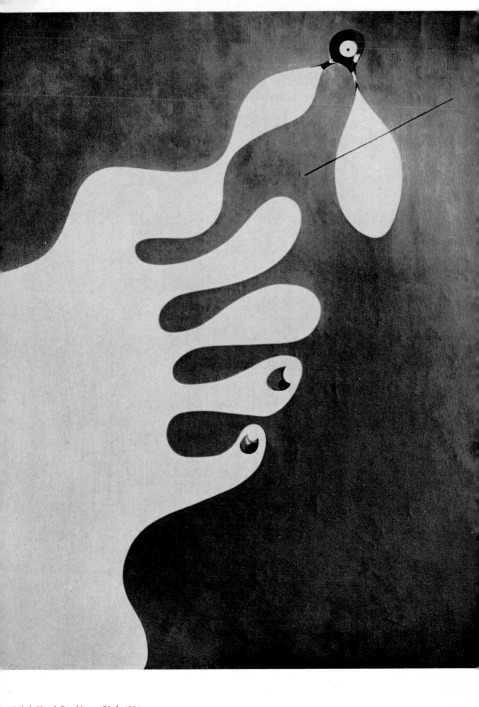

an Miró *Hand Catching a Bird*, 1926

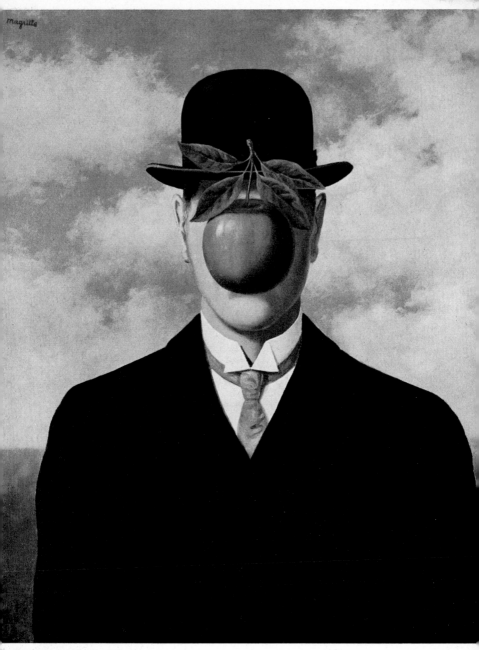

magritte

36 René Magritte *The Great War*, 1964

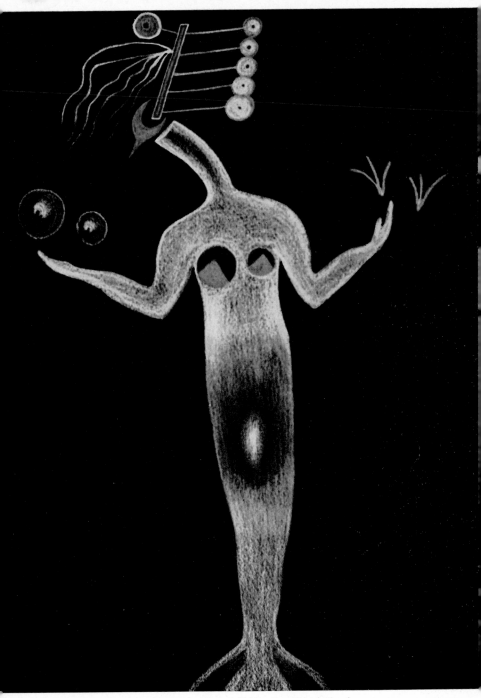

Exquisite Corpse, 1934, by Paul Eluard, Valentine Hugo, André Breton and Nusch Eluard

88 Joseph Šima *Composition*, 1928

89 Georges Malkine *The Lady of Pique*, 1928

90 Roland Penrose *The Invisible Isle*, 1936

91 Jacques Hérold *The Eagle-Reader*, 1942

92 Matta *Doubt's Pilgrim*, 1946

93 Wolgang Paalen *Medusan Landscape*, 1937

94 Matta *Intervision*, 1955

95 *Intervision* by Victor Brauner in collaboration with Matta, 1955

Dorothea Tanning *Two Words*, 1963

102 Dorothea Tanning *Palaestra*, 1947

103 Félix Labisse *The Future Revealed*, 1955

104 Marie-Laure *The Lions' Thirst*, 1962

105 Max Walter Svanberg *Kiss of the Dream-Woman*, 1959

106 Le Maréchal *The Monster of State*, 19

107 Arshile Gorky *Water of Flowery Mill*, 1944

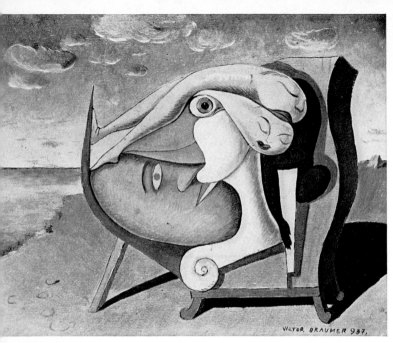

8 Victor Brauner *Untitled*, 1937

9 Edgar Ende *The End*, 1931

Surrealism and Painting

From *Le Surréalisme et la Peinture,* 1927

ANDRÉ BRETON

The eye exists in a natural state. The marvels of the earth seen from one hundred feet above, the marvels of the sea from one hundred feet below, can call as witness only the wild eye which relates all colour to the rainbow. It presides over the conventional exchange of signals apparently required for the navigation of the mind. But who will set up the scale of vision? There are those things which I have already seen many times, and which others likewise tell me they have seen, things I think I can recognize whether or not they matter to me – for example, the façade of the Paris Opera, a horse, the horizon; there are those things which I have only rarely seen and have not always chosen to forget (or not to forget, whichever the case may be); there are those things which, having gazed at them in vain, I never dare to see, which are all the things I love, in whose presence I no longer see the rest; there are those things which others have seen and say they have seen, and which they can or cannot make me see by suggestion; there are also those things which I see differently from everyone else, and those things which I am beginning to see but *are not visible.* And that is not all.

Corresponding to these varying degrees of sensation are spiritual realizations so precise and distinct as to permit me to grant plastic expression an importance which I shall always deny to musical expression, which is the most profoundly confusing of all.[1] In fact, auditory images are inferior to visual images not only in clarity but in precision, and, with all due respect to some megalomaniacs, they do not serve to strengthen the idea of human grandeur. So may night continue to fall upon the orchestra, and may I, who am still seeking something from the world, be left to my silent contemplation, with eyes open or closed, in broad daylight.

Now I confess that I have passed like a madman through the slippery halls of museums. But I am not the only one. In spite of some marvellous glances thrown to me by women similar in every way to those of today, I have not for an instant been fooled by what those subterranean and immovable walls had to offer me of the unknown. Without remorse I abandoned some charming suppliants. There were too many stages at once upon which I felt no urge to act. Passing by all those religious compositions, all those rustic allegories, I irresistibly lost the sense of my own role. Outside, the street prepared a thousand more real enchantments for me. I am not to blame if I cannot resist a profound lassitude when confronted by the interminable parade of rivals for that colossal Prix de Rome in which nothing, neither the subject nor the manner in which it is treated, remains optional.

I do not mean to say that no emotion can be extricated from a painting of 'Leda', that an agonizing sun cannot set in a scene of 'Roman Palaces', or even that it is impossible to impart some semblance of eternal morality to the illustration of a fable as ridiculous as *Death and the Woodcutter*. I think only that genius gains nothing from following these beaten paths and indirect routes.

Drawings by Maurice Henry, 1930 and 1934

At least such stakes are fruitless. Nothing is more dangerous to take liberties with than liberty.

But once we have passed the stage of emotion for emotion's sake, remember that for us in this day and age it is reality itself which is at stake. How can we be expected to content ourselves with the fugitive perplexity brought to us by such and such a work of art? There is not one work of art which holds up against our integral *primitivism* in this respect. When I know where the terrible struggle within me between living and likely to live will end, when I have lost all hope of enlarging the scope of reality – up to now completely confined – to stupefying proportions (by my own measure), when my imagination retires within itself and coincides only with my memory, I shall gladly grant myself, like the others, a few relative satisfactions. I shall go over to the 'embellishers'. I shall forgive them. But not before!

Artistic Genesis and Perspective of Surrealism

Early in 1925, several months after the publication of the *First Surrealist Manifesto* and several years after that of the first surrealist texts *(Magnetic Fields* first appeared in *Littérature* in 1919), the possibility of a painting which could satisfy surrealist demands was still being discussed. While some denied that a surrealist painting could exist, others were inclined to think that it could be found in embryonic form in certain recent works, or even that it existed already. Aside from whatever it might have owed at this time to Chirico in the direction of dream, to Duchamp in the acceptance of chance, to Arp, to Man Ray in his photographic *Rayograms*, to Klee in the direction of (partial) automatism, we can easily see now that surrealism was already in full force in the work of Max Ernst. In fact, surrealism found itself immediately in his 1920 collages, which expressed an absolutely virgin proposition of visual organization, corresponding to what Lautréamont and Rimbaud had sought in poetry. I remember the emotion – never again experienced in the same way – which seized Tzara, Aragon, Soupault and myself at their discovery; I happened to be at Picabia's when they arrived from Cologne. The external object had broken with its customary surroundings, its component parts were somehow emancipated from the object in such a way as to set up entirely new relationships with other elements, escaping from the principle of reality while still drawing upon the real plane (and overthrowing the idea of correspondence). Guided by the

prodigious rays which he was the first to make visible, Max Ernst in his first canvases agreed to take great risks. Each one is dependent to a minimum upon the others, and the general effect is in response to the same conception as the poems written by Apollinaire from 1913 to the war, each of which carries the weight of an *event* in itself. Later, when he arrived at some assurance of the profound meaning of his course and the means of its realization, Max Ernst still did not swerve from the urgent necessity of forever 'finding something new', as Baudelaire put it. His work – as its power has steadily increased over these last twenty years – has no equivalent from the point of view of *will*.

Automatism, inherited from the mediums, remains one of the two major trends of surrealism. Since it has excited and still excites the most violent polemics, it is not too late to attempt to penetrate a little further into its function and to try to put across a decisive argument in its favour. In terms of modern psychological research, we know that we have been led to compare the construction of a bird's nest to the beginning of a melody which tends towards a certain characteristic conclusion. A melody imposes its own structure, in as much as we distinguish (in spite of their interference) the sounds that belong to it and those that are foreign to it, and for all that it is perceived by its own quality, which is totally different from the sum of its component qualities. I maintain that graphic as well as verbal automatism – without damage to the profound individual tensions which it is capable of manifesting and to some extent of resolving – is the only mode of expression which fully satisfies the eye or ear by achieving *rhythmic unity* (just as recognizable in the automatic drawing and text as in the melody or the nest). It is the only structure that responds to the non-distinction – better and better established – between sentient and formal qualities, and to the non-distinction – also better and better established – between sentient and intellectual functions, which is why it alone can equally satisfy the mind. And I agree that automatism can enter into composition, in painting as in poetry, with certain premeditated intentions; but there is a great risk of departing from surrealism if the automatism ceases to flow *underground*.[2] A work cannot be considered surrealist unless the artist strains to reach the total psychological scope of which consciousness is only a small part. Freud has shown that there prevails at this 'unfathomable' depth a total absence of contradiction, a new mobility of the emotional blocks caused by repression, a timelessness and a substitution of psychic reality for external reality, all subject to the principle of pleasure alone. Automatism leads straight to this region. The other route offered to surrealism, the so-called 'trompe l'oeil' (wherein lies its weakness)

fixation on dream images, has been confirmed by experience to be far less safe, and even very susceptible to risks of being led astray.

When Dali introduced himself to surrealism in 1929, nothing strictly personal had been augured by his previous work. On the theoretical plane he proceeded to change that by means of borrowings and juxtapositions, the most striking example of which is the amalgam – under the name of 'paranoiac critical activity' – of the lessons of Piero di Cosimo and Leonardo da Vinci (absorbing oneself in the contemplation of a blob of spittle or an old wall until the eye begins to perceive a *second* world, which can be equally well revealed by painting), and of methods – along the lines of *frottage* – already recommended by Max Ernst to 'intensify the irritability of the mental faculties'. In spite of an undeniable ingenuity in his staging, Dali's venture, ill served by an ultra-retrogade technique (return to Meissonier) and discredited by a cynical indifference regarding ways of imposing himself on the public, has shown signs of panic for a long time now and has only been salvaged momentarily by the organization of its own vulgarities. Today it flounders in academicism – an academicism declared classicism on its own authority alone – and in any case it has held no interest at all for surrealism since 1936.

The Crisis of the Object

Just as contemporary physics tends to be based on non-Euclidian systems, the creation of 'surrealist objects' responds to the necessity of establishing, according to Paul Eluard's decisive expression, a veritable 'physics of poetry'. Likewise, there will now be found side by side on the tables of the mathematical institutes of the world objects – some constructed on Euclidian ideas, others not; but both equally confusing to the layman – that maintain to no lesser degree the most passionate and equivocal relationships in space as we generally conceive it. The objects which assume their places within the framework of the surrealist exhibition of May 1936[3] are above all likely to *lift the prohibition* resulting from the overpowering repetition of those objects which meet our glance daily and persuade us to reject as illusion everything that might exist beyond them. It is important to strengthen at all costs the defences which can resist the invasion of the feeling world by things used by men more out of habit than necessity. Here as elsewhere the mad beast of *custom* must be hunted down. These means are at hand; common sense can only create the world of concrete

objects on which its odious supremacy is based, although undermined and badly guarded on all sides. Poets and artists meet with scholars at the heart of those 'fields of force' created in the imagination by the bringing together of two different images. This ability to bring together two images permits them to go beyond the usually limiting consideration of the object's known life. In their eyes the object, no matter how complete, returns to an uninterrupted succession of *latencies* which are not peculiar to it and which invoke its transformation. For them the conventional value of this object disappears behind its representational value, which leads them to emphasize its picturesque side, its evocative power. 'What', writes M. Bachelard, 'is belief in reality, what is the idea of reality, which is the primordial metaphysical function of the real? It is essentially the conviction that an entity exceeds its immediate known quantity, or, to put it more clearly, it is the conviction that *there is more to be found in the hidden real than in the immediate known quantity.*' Such an affirmation is sufficient to justify strikingly the surrealist course leading to the instigation of a *total revolution of the object:* acting to divert the object from its ends by coupling it to a new name and by signing it, which entails requalification by choice (Marcel Duchamp's 'ready-mades'); by showing it in the condition in which external agents such as earthquakes, fire and water have sometimes left it; by retaining it because of the very uncertainty of its previous assignment or the ambiguity resulting from its totally or partially irrational conditioning, which gains dignity by discovery (found object) and leaves an appreciable margin in the case of the most active kind of interpretation (Max Ernst's interpreted found object); and finally, by reconstructing it from all the pieces starting with dispersed elements captured from the immediate known quantity (surrealist object, properly speaking). Perturbation and deformation are in demand here for their own sakes, though it is acknowledged that only constant and lively readjustment of the *law* can be expected of them.

Objects thus reassembled have in common the fact that they derive from, and succeed in differing from, the objects which surround us by simple *change of role.* Still, nothing is less arbitrary if we bear in mind that it is only the very special act of taking this role into consideration which permits the resolution of Renouvier's 'dilemma of substance': passage from substantive to substance through the medium of a third term, 'specialized substantive'.

It would be falling back into the trap of rationalism to claim to compare mathematical objects – catalogued by their constructors in the sterile standard terms: *Allure of elliptical function P^1 (U) for $G^2 = O$ and $G^3 = 4$* – to poetic objects, which answer to more attractive designations. Let us observe, in passing,

that the philosophy which gave life to the poetic objects moved with a steady rush from abstract to concrete when one part of contemporary art (abstraction) persisted in taking the opposite direction and – as by the publication of similar documents – put itself in the position of seeing its realizations decisively outclassed.

Decalcomania Without Preconceived Object
(Decalcomania of Desire)

The suddenly more opaque forest that takes us back to the days of Geneviève de Brabant, Charles VI and Gilles de Rais, then offers us the giant thistle of its glades, a certain sublime point in the mountain, naked shoulders, froth and needles, delirious boroughs of grottoes, black lakes, will-o'-the-wisps on the moors, all that is glimpsed in the early poems of Maeterlinck and Jarry, floating heaps of sand, rocks caressed and uncaressed by dynamite, heads eternally in hands, submarine flora, unfathomable fauna which parody human endeavour (representation and comprehension). I might take as a model that monster with a triple-hooked beak (armed for fishing with a line?) which explodes like a burst of laughter at our expense when it is raised again to the surface. Everything that defies plastic figuration because of its complexity, its minutiae, its instability, artistic imitation of which would seem rather fastidious and childish when only a tuft of moss is concerned – everything that could be called 'a painter's despair' (or a photographer's) is now returned to us as a result of a recent communication from our friend Oscar Dominguez, in which surrealism is pleased to behold a new source of emotion *for everyone*. Even now children seek to capture the illusion of certain animal or vegetable beings or suggestions by folding blank paper freshly spotted with ink, but elementary techniques have far from exhausted the resources of such a process. The use of undiluted ink in particular excludes any surprise in the 'matter' or substance, and as a result only a contour drawing can be assured. Furthermore, the repetition of symmetrical forms, due to the axis of the fold, produces monotony. Certain of Victor Hugo's wash drawings seem to testify to systematic research in the direction that interests us: an unequalled power of suggestion can clearly be expected from the completely involuntary mechanical themes which preside over them. But for the most part they are still no more than Chinese shadows and cloud phantoms. Oscar Dominguez's discovery builds upon and extends this method in order

to obtain ideal opportunities for interpretation. The spell under which we were held by Arthur Rackham's rocks and willows when emerging from childhood is rediscovered here in the purest state. Once again, this is a receipt *within everyone's reach* which demands to be incorporated into the 'Secrets of the Art of Surrealist Magic' and can be formulated as follows:

How to Open at Will the Window onto the Most
BEAUTIFUL LANDSCAPES IN THE WORLD AND ELSEWHERE

With a large brush spread black gouache, more or less diluted in places, on a sheet of smooth white paper that you will immediately cover with a similar sheet on which you exert a medium pressure with the back of your hand. Lift this second sheet slowly by its upper edge, just as you would proceed in decalcomania; refrain from reapplying it and raising it again until drying is almost complete. What you have before you is perhaps only da Vinci's old paranoiac wall, but it is this wall perfected. It may suffice, for example, to entitle the image obtained according to what you discover there, first withdrawing somewhat in order to ensure the most personal and valuable expression.

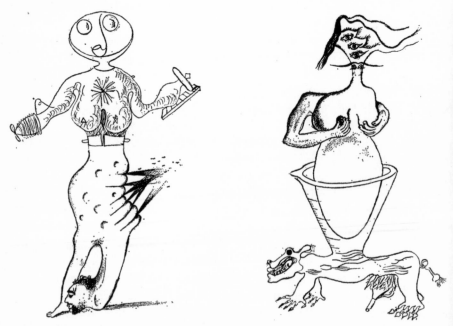

Drawings for *The Exquisite Corpse* by Victor Brauner, André Breton, Jacques Hérold and Yves Tanguy, 1935.

Food for Vision

From *Donner à Voir*, 1939.

Beyond Painting

Paul Eluard

Around 1919, when the imagination sought to rule and subdue the dismal monsters strengthened by war, Max Ernst resolved to bury old Reason, which had caused so many discords and disasters, not under its own ruins – from which it makes monuments – but under the free representation of a freed universe.

It is not far – as the crow flies – from cloud to man; it is not far – by images – from man to what he *sees*, from the nature of real things to the nature of imagined things. They are of equal value. Matter, movement, need, desire are inseparable. The honour of living is well worth some exertion to give life. Think of yourself as flower, fruit, and heart of a tree, since they wear your colours, since they are one of the necessary signs of your presence. Only when you have ceased to ascribe ideas to it will you be granted the belief that everything is transmutable into everything.

A truly materialist interpretation of the world cannot exclude from that world the person who verifies it. Death itself concerns him, the living person, the living world.

I do not know if a poet has ever been more deeply affected by these fundamental truths than Max Ernst. And this is a prime reason to regard and admire this painter as a very important poet. In his collages, frottages and paintings he ceaselessly exercises the will to confuse forms, events, colours, sensations, sentiments – the trifling and the grave, transitory and permanent, old and new, contemplation and action, men and objects, time and duration, element and entirety, nights, dreams and light.

Max Ernst has mingled with and identified himself with his work. By carrying his insight beyond this unfeeling reality to which we are expected to

resign ourselves, he ushers us as a matter of course into a world where we consent to everything, *where nothing is incomprehensible.*

Hands Free

Basket, white night. And the deserted beaches of a dreamer's eyes. The heart trembles.

Man Ray's drawings: always desire, not necessity. Not a wisp of down, not a cloud, but wings, teeth, claws.

There are as many marvels in a glass of wine as at the bottom of the sea. There are more marvels in an eager hand held out than in all that separates us from what we love. Let us not perfect or embellish what is opposed to us.

A mouth around which the earth turns.

Man Ray paints in order to be loved.

Miró's Beginnings

When the bird of day just freshly flying came to nest in the colour tree, Miró tasted the pure air, the fields, milk, herds, simple eyes and tenderness of the glorious breast gathering the mouth's cherry. No windfall was ever better to him than an orange and mauve road, yellow houses, pink trees, the earth, on this side of a sky of grapes and olives which will breach four walls and boredom for a long time.

When I first met one of the two women I have known best – have I known any others? – she had just fallen in love with a painting by Miró, *The Spanish Dancer.* A more naked picture cannot be imagined: on the virgin canvas, a hat pin and a wing feather.

First morning, last morning, the world begins. Shall I isolate, obscure myself in order to reproduce more faithfully quivering life? Words that I would like outside cling to me at the heart of this innocent world which speaks to me, sees me, listens to me, and whose most transparent metamorphoses Miró has always reflected.

Conquest of the Irrational

From *La Conquête de l'Irrationnel*, 1935

SALVADOR DALI

It was in 1929 that Salvador Dali fixed his attention on the internal mechanisms of paranoiac phenomena, envisioning the possibility of an experimental method based on the unexpected power of those systematic associations peculiar to paranoia; this method subsequently became the delirious-critical synthesis which bears the name 'paranoiac-critical activity'. Paranoia: delirium of interpreative association permitting a systematic structure. Paranoiac-critical activity: spontaneous method of irrational understanding based upon the interpretative critical association of delirious phenomena.

The presence of the active and systematic elements peculiar to paranoia ensures the evolutionary and productive character peculiar to paranoiac-critical activity. The presence of active and systematic elements does not imply the idea of voluntarily directed thinking, nor of any intellectual compromise, for, as we know, in paranoia the active and systematic structure is consubstantial with the delirious phenomenon itself – every delirious phenomenon of a paranoiac nature, even if instantaneous and unexpected, already comprises the systematic structure 'in full' and only objectivizes itself *a posteriori* by critical intervention. Critical activity intervenes uniquely as a developing fluid for systematic and serious images, associations, conjunctions and niceties already extant at the moment when delirious instantaneity is produced, which is momentarily, at this degree of tangible reality, the only thing that paranoiac-critical activity allows to be brought back to objective light. Paranoiac-critical activity is an organizational and productive force of objective chance. Paranoiac-critical activity no longer deals with surrealist phenomena and images in isolation, but rather considers them in a coherent unity of systematic and significant relationsl.ips. In contrast to the passive, disinterested, contemplative and aesthetic attitude of irrational phenomena, the active, systematic, organizational,

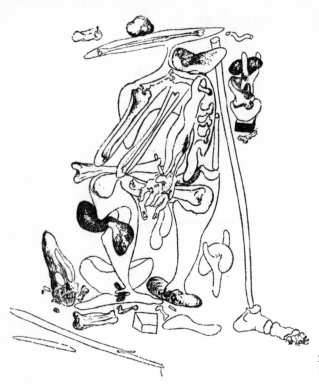

Drawing by Salvador Dali for
Lautréamont's *Songs of Maldoror.*

cognizant attitude of these same phenomena are considered as associative, partial and significant events in the authentic domain of our immediate and practical experience of life.

Paranoiac phenomena: the well-known images of double figuration – figuration can be theoretically and practically multiplied – all depend on the paranoiac capacity of the author. The basis of associative mechanisms and the renewal of obsessive ideas permits, as is the case in a painting by Salvador Dali, the representation of six simultaneous images without any one of them undergoing the least figurative deformation – athlete's torso, lion's head, general's head, horse, bust of a shepherdess, death's head. Different viewers see different images in this picture; it goes without saying that the treatment is scrupulously realistic.

The Exquisite Corpse

From *Le Cadavre Exquis: Son Exaltation*, 1948

ANDRÉ BRETON

The Exquisite Corpse was born, if we remember correctly (and if that is the proper expression), around 1925 in the old house at 54 rue du Château, since destroyed. There Marcel Duhamel, long before devoting himself to the perusal of American literature, made enough from his whimsical (if grandiose) participation in the hotel industry to lodge his friends Jacques Prévert and Yves Tanguy, who did not yet excel at anything except the art of living, while enlivening everything with their spirited outbursts. For a while Benjamin Péret also stayed there. Absolute non-conformism and universal disrespect was the rule, and great good humour reigned. It was a time for pleasure and nothing else. Almost every evening we gathered around a table where Château-Yquem deigned to mingle its suave note with that of other, equally tonic local brews.

When the conversation – on the day's events or proposals of amusing or scandalous intervention in the life of the times – began to pall, we would turn to games; written games at first, contrived so that elements of language attacked each other in the most paradoxical manner possible, and so that human communication, misled from the start, was thrown into the mood most amenable to adventure. From then on no unfavourable prejudice (in fact, quite the contrary) was shown against childhood games, for which we were rediscovering the old enthusiasm, although considerably amplified. Thus, when later we came to give an account of what had sometimes seemed upsetting to us about our encounters in this domain, we had no difficulty in agreeing that the *Exquisite Corpse* method did not visibly differ from that of 'petits papiers'. Surely nothing was easier than to transpose this method to drawing, by using the same system of folding and concealing.

EXQUISITE CORPSE: *Game of folded paper played by several people, who compose a sentence or drawing without anyone seeing the preceding collabo-*

ration or collaborations. The now classic example, which gave the game its name, was drawn from the first sentence obtained this way: The-exquisite-corpse-will-drink-new-wine.

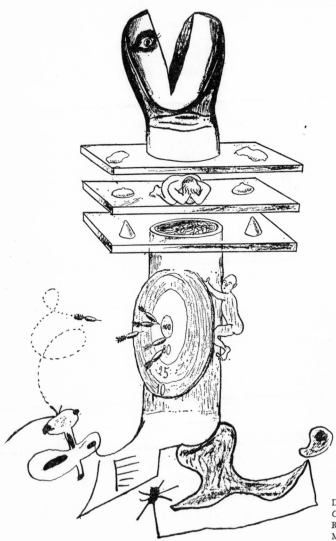

Drawing for *The Exquisite Corpse* by Yves Tanguy, Man Ray, Max Morise and Joan Miró, *c.* 1926.

Ill-disposed critics in 1925–1930 gave further example of their ignorance when they reproached us for delighting in such childish distractions, and at the same time suspected us of having produced such monsters in broad daylight, individually, and more or less laboriously. In fact, what excited us about these productions was the assurance that, for better or worse, they bore the mark of something which could not be created by one brain alone, and that they were endowed with a much greater *leeway*, which cannot be too highly valued by poetry. Finally, with the *Exquisite Corpse* we had at our command an infallible way of holding the critical intellect in abeyance, and of fully liberating the mind's metaphorical activity.

All of this is as valid on the graphic as on the verbal plane. We must add that along the way a considerable enigma arose, posed by the frequent encounter of elements with similar associational origins in the course of the collective production of a sentence or a drawing. This encounter not only provoked a vigorous play of often extreme discordances, but also supported the idea of communication between the participants – tacit, but in waves; this would have to be reduced to its rightful limits by control of the estimate of probabilities, but in the final analysis we believe that this communication tends to be confirmed as fact.

Because of the pre-determined decision to *compose a figure*, drawings complying with the *Exquisite Corpse* technique, by definition, carry anthropomorphism to its climax, and accentuate tremendously the life of correspondences that unites the outer and inner worlds. These drawings represent total negation of the ridiculous activity of imitation of physical characteristics, to which a large and most questionable part of contemporary art is still anachronistically subservient. If only some salutary precepts of indocility might be opposed to its present array, take offence at the exclusion of all humour, and bring it around to a less larval sense of its means.

[From the catalogue of an exhibition at La Dragonne, Galerie Nina Dausset, Paris, 7–30 October 1948, entitled *Le Cadavre Exquis: Son Exaltation,* p. 5–7, 9–11.]

Beyond Painting

From *Au-delà de la peinture*, 1936; first published in *Cahiers d'Art*, Max Ernst, Special Issue, 1937

MAX ERNST

10 August 1925

Botticelli did not like landscape painting, regarding it as a 'limited and mediocre kind of investigation'. He said contemptuously that 'by throwing a sponge soaked with different colours at a wall one can make a spot in which a beautiful landscape can be seen'. This earned him a severe admonition from his colleague Leonardo da Vinci:

'He [Botticelli] is right: one is bound to see bizarre inventions in such a smudge; I mean that he who will gaze attentively at that spot will see in it human heads, various animals, a battle, rocks, the sea, clouds, thickets, and still more: it is like the tinkling of a bell which makes one hear what one imagines. Although that stain may suggest ideas, it will not teach you to complete any art, and the above-mentioned painter [Botticelli] paints very bad landscapes.

'To be universal and to please dissimilar tastes, dark and gently shaded sections must both be found in one composition. In my opinion it does no harm to remember, when you stop to contemplate the spots on walls, certain aspects of ashes on the hearth, of clouds or streams; and if you consider them carefully you will discover most admirable inventions which the painter's genius can turn to good account in composing battles (both of animals and men), landscapes or monsters, demons and other fantastic things that will do credit to you. Genius awakes to new inventions in these indistinct things, but one must know how to depict all the members not included there, such as the parts of animals and aspects of landscape, rocks and vegetation' (*Treatise on Painting*).

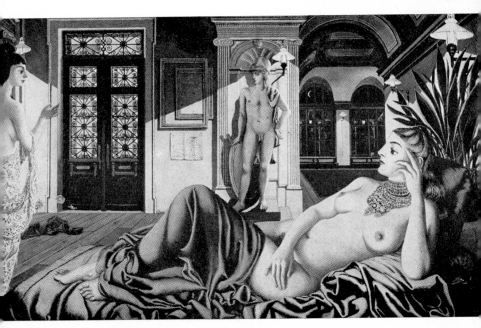

Paul Delvaux *In praise of Melancholy*, 1951

12 Max Ernst *The Start of the Chestnut Tree*, 1925

13 André Breton *The Comte de Foix Going to Assassinate His Son*, 1929

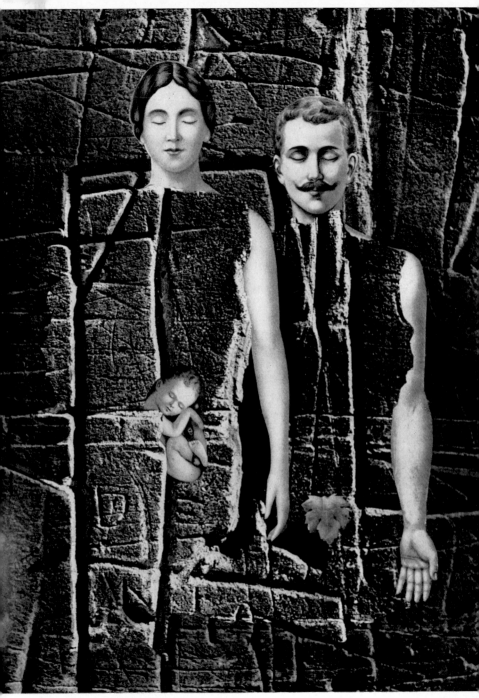

Jacques Prévert *Man Woman and Child*, 1958

115 Paul Eluard *Modern Times*, 1937

116 Jacques Prévert *The pleasures of Progress*, 1958

117 E. L. T. Mesens *Handsight*, 1951

118 Sculpture by Jean-
Pierre Duprey, 1958

119 Max Ernst *Chimera*, 1935

120 Jean Arp *Head-moustache, Moustaches and Mask*, 1930

121 Alberto Giacometti *The Palace at 4 a.m.*, 1932/33

122 Alberto Giacometti
The Invisible Object
1935

123 Man Ray *Burnt Bridges*, 1935

124 Jean Arp *Mutilated and Homeless*, 1936

an Arp *Bundle from a Shipwreck*, 1921

126 Max Ernst *Aeolian Harp*, 1963

127 André Breton *Object-poem*, 1937

128 Salvador Dali *Aphrodisiac Jacket*, 1936

129 Meret Oppenheim *Lunch in Fur*, 1938

130 Oscar Dominguez *Peregrinations of G. H.*, 1936

131 Wolfgang Paalen *On the Ladder of Desire*, 1936

lexander Calder *Arch Constellation*, 1943

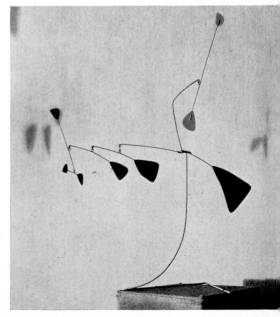

133 Alexander Calder *Blue-Red Horizontals, Yellow Verticals*,
1953/54

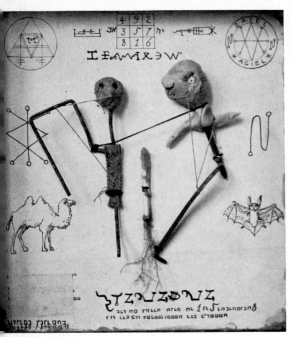

134 Victor Brauner *The Lovers*, 1943

135 Maurice Baskine *Phototron with Mirror*, 1957 (in mirror: the artist)

136 Maurice Henry *Homage to Paganini*, 1936

137 Maurice Henry *Eurydice's Crossing*, 1962

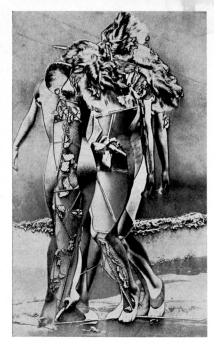

138 Dora Maar *29 Rue d'Astorg*, 1936 (photomontage) 139 Raoul Ubac *Solarisation*, 1937 (photograph)

140 Oscar Dominguez *Decalcomania without Preconceived Object*, 1937

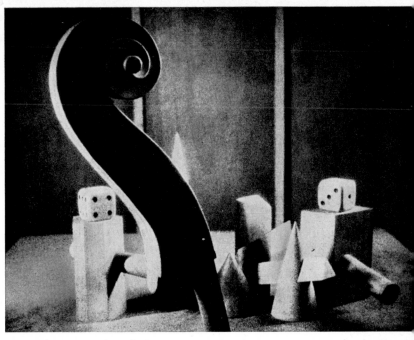

141 Scene from *Emak Bakia*, a film by Man Ray, 1927

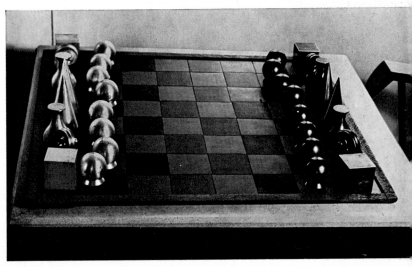

142 Man Ray *Chess-set*, 1926

143 Scene from *Un Chien Andalou,* a film by Luis Buñuel, 1929

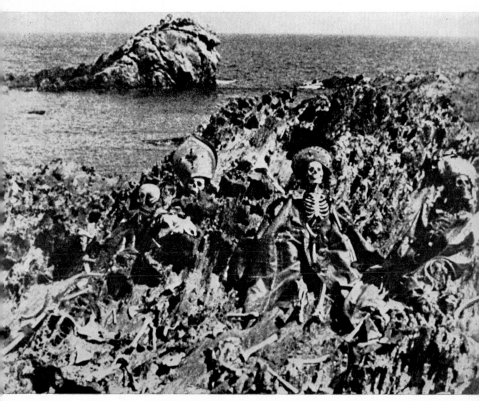

144 Scene from *L'Age d'Or*, a film by Luis Buñuel, 1932

On 10 August 1925 an overpowering visual obsession led me to discover the technical means which gave me a wide range for putting Leonardo's lesson into practice. Departing from a childhood memory in the course of which a false mahogany panel facing my bed played the role of optical *provocateur* in a vision of near-sleep, and finding myself one rainy day in an inn by the seacoast, I was struck by the obsession exerted upon my excited gaze by the floor – its grain accented by a thousand scrubbings. I then decided to explore the symbolism of this obsession and, to assist my contemplative and hallucinatory faculties, I took a series of drawings from the floorboards by covering them at random with sheets of paper which I rubbed with a soft pencil. When gazing attentively at these drawings, I was surprised at the sudden intensisification of my visionary faculties and at the hallucinatory succession of contradictory images being superimposed on each other with the persistence and rapidity of amorous memories.

As my curiosity was now awakened and amazed, I began to explore indiscriminately, by the same methods, all kinds of material – whatever happened to be within my visual range – leaves and their veins, the unravelled edges of a piece of sackcloth, the brushstrokes of a 'modern' painting, thread unrolled from the spool, etc., etc. Then my eyes perceived human heads, various animals, a battle ending in a kiss (*Fiancé of the Wind*), rocks, *The Sea and the Rain*, *Earthquakes*, *The Sphinx in her Stable*, *Little Tables around the Earth*, *Caesar's Palette*, *False Positions*, an *Ice-Flower Shawl*, *Pampas*.

Whip Lashes and Threads of Lava, *Fields of Honour*, *Floods and Seismic Plants*, *Scarecrows*, *The Sprinting Chesnut Tree*.

Teenage Lightning, *Vaccinated Bread*, *Conjugal Diamonds*, *The Cuckoo*, *Origin of the Pendulum*, *Dead Man's Meal*, *Wheel of Light*.

A Solar Money System.

The Habits of Leaves, *The Fascinating Cypress*.

Eve, the Only One Left to Us.

I collected the first results of the frottage process from *The Sea and the Rain* to *Eve, the Only One Left to Us* under the title *Natural History* (published by Jeanne Bucher in 1926).

I emphasize the fact that in the course of a series of spontaneously exposed suggestions and transmutations (like hypnagogical visions), drawings obtained by frottage lose more and more of the character of the material explored (wood, for example) to take on the aspect of unexpectedly precise images whose nature probably reveals the initial cause of the obsession or a semblance of that cause.

The frottage process – based on nothing other than the intensification of the irritability of the mind's faculties by appropriate technical means, excluding all conscious mental guidance (of reason, taste or morals) and reducing to a minimum the active part of what has hitherto been called the 'author' of the work – was consequently revealed as the true equivalent of that which was already known as *automatic writing*. The author is present at the birth of his work as an indifferent or passionate spectator and observes the phases of its development. Just as the role of the poet, ever since the celebrated *Letter of a Clairvoyant,* consists of taking down, as though under dictation, all that is articulated within him, so the painter's role is to outline and *project what is visible within him.* [1] By devoting myself more and more to this activity (passivity), which was later called 'paranoiac criticism' [2], and by adapting the frottage process, which had at first appeared applicable only to drawing, to the medium of painting (by scraping pigment on to a colour-prepared foundation placed on an uneven surface), and by increasingly trying to restrain my own active participation in the development of the painting so as to enlarge the active part of the mind's hallucinatory faculties, I succeeded in simply attending as a spectator the birth of all my works, [3] beginning with that memorable day when I discovered frottage – 10 August 1925. Being a man of 'ordinary constitution' (to use Rimbaud's term), I have done everything to *make my soul monstrous.* Blind swimmer, I have made myself a seer. *I have seen.* And I caught myself falling in love with what *I saw* and wanting to identify myself with it.

In a country the colour of '*a pigeon's breast*' I hailed the flight of *100,000 doves.* I saw them invade the black *forests* of desire and endless *walls* and *seas.*

I saw an *ivy leaf floating on the ocean* and I felt a *gentle earthquake,* and I saw a *pale dove, flower of the desert.* She *refused to understand.* A superb man and woman danced the *Carmagnole of love along a cloud.*

The dove *folded herself in her wings* and swallowed the key forever.

A string found on my table made me see a number of *young people trampling their mother,* and several *young girls* amusing themselves *in beautiful poses.*

Some very beautiful women crossing a river and crying. A man walking on the water took one young girl by the hand and jostled another. People with a rather reassuring look – indeed, *they had lain too long in the forest* – were making their *savage gestures only for charm's sake.* Someone said '*The Immobile Father*'.

The Beak Couple, colour etching by Max Ernst, 1957. Forest and Sun, colour lithograph by Max Ernst, 1957.

Then I saw myself, *showing my father's head to a young girl.* The earth only quaked softly.

I decided to erect a *monument to the birds.*

It was summer, *the beautiful season.* It was the time of *serpents, earthworms, feather-flowers, scale-flowers, tube-flowers.* It was the time when *the forest took flight and flowers argued under water.* The time of the *circumflex Medusa.*

In 1930, after having composed my novel *La Femme 100 Têtes* with systematic violence, I was visited nearly every day by the *Bird Superior,* named *Loplop,* an extraordinary phantom of model fidelity who attached himself to my person. He presented me with a *heart in a cage,* the *sea in a cage, two petals, three leaves, a flower and a young girl.* As well as *the man with black eggs* and *the man with the red cloak.* One fine autumn afternoon he informed me that one day *a Lacedaemonian had been invited to go and hear a man who imitated the nightingale perfectly. The Lacedaemonian replied: I have often heard the nightingale itself.* One evening he told me jokes which were not laughing matters: '*Joke – it is better not to reward a good deed at all than to reward it badly. A soldier had had both arms blown off in combat. His*

colonel offered him a gold piece. The soldier replied: I suppose you think, Sir, that I've only lost a pair of gloves.'

I had already said *hello to Satan* in 1928. An unavowable *old man was loaded down at that time with a package of clouds on his back,* while a flower in white lace, *its neck pierced by a stone,* stayed very still as it *sat on a tambourine. Why am I not that charming flower?* Why must I always change into an *earthquake,* into an *ace of hearts,* into a *shadow entering by the door.*

Dark vision: *Europe after the Rain!*

On 24 December 1933 I was visited by a *young chimaera in an evening gown.* Eight days later I met a *blind swimmer.*

A little patience (15 days' wait) and I will be present at the *dressing of the bride.* The *bride of the wind* will embrace me in passing at a full gallop *(simple effect of touch).*

I saw *barbarians looking to the west, barbarians leaving the forest, barbarians marching to the west.* On my return from the *garden of the Hesperides* I followed with ill-concealed joy the phases of a *combat between two bishops.* It was as beautiful as the chance meeting of a sewing machine and an umbrella on a dissecting table.

I caressed: *The lioness of Belfort.*
The antipode of the landscape.
A beautiful German girl.
Wheat germ landscapes.
Lunar asparagus.
The straits of Mars.
The absolute presence.

Voracious gardens devoured by a vegetation which is the debris of wrecked airplanes.

I saw myself with the head of a kite bird, knife in hand, in the pose of Rodin's *Thinker,* so I thought, but it was actually the liberated pose of Rimbaud's *Seer.*

I saw with my own eyes *the nymph Echo.*

I saw with my own eyes the appearances of things retreating, and I experienced a calm and ferocious joy. Within the bounds of my activity (passivity) I have contributed to that general overthrow of the most firmly established and secured values which is taking place in our time.

bloody uprising she flowers into grace and truth': from *La Femme 100 Têtes* by Max Ernst, 1929.

Text References

INTRODUCTION (Convulsive Beauty)

1 *Cf.* V. Hugo, *Promontorium Somnii*, Commentary by René Journet and Guy Robert, Paris, 1961.
2 Baudelaire, who himself used the word 'surnaturalism', indicated very precisely that 'pure art' has as its objective to 'create a suggestive magic', 'an enchantment', or even 'astonishment'. *Cf.* Georges Blin, *Le Sadisme de Baudelaire*, Paris, 1948, p. 99.
3 This book, which for the first time raised questions concerning the relationships between surrealism and art, was first published in serial form in *La Révolution Surréaliste* (Nos. 4, 6, 7, 9, 10). One may believe that it was not written without difficulty, since its publication is spread out over two years (1925–27). A completed edition appeared in the *Editions de la Nouvelle Revue Française* in 1928. Finally, in 1945, *Surrealism and Painting* was reissued under the same title by Brentano's in New York, augmented by various texts on art and by *Genesis and Perspective of Surrealism* (the English translation of which was used as the introduction to an exhibition catalogue for the Guggenheim museum, *Art of this Century*, 1941). It is to this last edition that I shall refer hereafter.

FIRST MANIFESTO

1 We must take into consideration the *thickness* of the dream. I usually retain only that which comes from the most superficial layers. What I prefer to visualize in it is everything that sinks at the awakening, everything that is not left to me of the function of that preceding day, dark foliage, absurd branches. In 'reality', too, I prefer to *fall*.
2 Had I been a painter, this visual representation would undoubtedly have dominated the other. It is certainly my previous disposition which decided it. Since that day I have had occasion to concentrate my attention voluntarily on similar apparitions, and I know that they are not inferior in clarity to auditory phenomena. Armed with a pencil and a blank sheet of paper, it would be easy for me to follow its contours. This is because here again it is not a matter of drawing, *it is only a matter of tracing*. I would be able to draw quite well a tree, a wave, a musical instrument – all things of which I am incapable of furnishing the briefest sketch at this time. Sure of finding my way, I would plunge into a labyrinth of lines which at first would not seem to contribute to anything. And upon opening my eyes I would experience a very strong impression of '*jamais vu*'. What I am saying has been proved many times by Robert Desnos. To be convinced of this, one has only to thumb through No. 36 of *Feuilles Libres*, which contains several of his drawings (*Romeo and Juliet, A Man Died This Morning*, etc.). They were taken by this review as drawings of the insane and innocently published as such.

3 Knut Hamsun attributes the kind of revelation by which I have just been possessed to *hunger*, and he may well be right. (The fact is that I was not eating every day at that period.) Unquestionably the manifestations that he describes below are the same as mine:

'The next day I awoke early. It was still dark. My eyes had been open for a long time when I heard the clock in the flat overhead sound five o'clock. I wanted to go back to sleep, but had no success. I was completely awake and a thousand things ran through my mind.

'All of a sudden several good pieces came to me, just right for use in a sketch or article. I found abruptly, and by chance, very beautiful phrases, phrases such as I had never written. I repeated them to myself slowly, word for word: they were excellent. And they kept coming. I rose and took a piece of paper and pencil to the desk behind my bed. It was as though a vein had burst in me, one word followed another, set itself in place, adapted itself to the situation, scenes accumulated, action unfolded, replies surged in my brain. I enjoyed myself prodigiously. Thoughts came to me so rapidly and continued to flow so abundantly that I lost a multitude of delicate details because my pencil could not go fast enough, and even then I was hurrying, my hand was always moving. I didn't lose a minute. Sentences continued to be driven from me, I was at the heart of my subject.'

Apollinaire affirmed that Chirico's paintings had been executed under the influence of cenesthesiac pains (migraines, colic).

4 I believe increasingly in the infallibility of my thought in regard to myself, and it is too accurate. Nevertheless, in this *writing down of thoughts,* where one is at the mercy of the first exterior distraction, 'transports' can be produced. It would be inexcusable to seek to ignore them. By definition, thought is strong and incapable of being at fault. We must attribute those obvious weaknesses to suggestions which come from outside.

5 And also by Thomas Carlyle in *Sartor Resartus* (Chapter VIII: 'Natural Supernaturalism'), 1833–34.

6 See also l'IDÉORÉALISME by Saint-Pol-Roux.

SECOND MANIFESTO

* *Translator's note:* This date is often given as 1930. However the manifesto was first published in *La Révolution Surréaliste,* No. 12, December 1929.

1 For some time now false quotation has been one of the methods most frequently employed against me. I give you as an example the manner in which *Le Monde* thought it could make the best of this sentence: 'Claiming to consider problems of love, dream, madness, art and religion in the same light as that of the revolutionaries, Breton has the nerve to write . . . etc.' It is true that, as one can read in the following issue of the same sheet, '*La Révolution Surréaliste* takes us to task in their last number. It is well known that these people's foolishness is absolutely unlimited.' (Especially since they have declined, without even bothering to reply, your invitation to contribute to *Le Monde?* But so be it.) Similarly, a contributor to the *Exquisite Corpse* sharply reprimands me under the pretext that I wrote: 'I vow never to wear the French uniform again.' *I'm sorry, but that was not me.*

SURREALISM AND PAINTING (Decalcomania)

1 On his deathbed Mozart declared that he 'was beginning to see what could be accomplished in music' (Poe).

2 For further reference see *Le Manifeste du Surréalisme* (1924), *Le Second Manifeste du Surréalisme* (1929), 'Letter to Roland de Renéville' and 'The Automatic Message' in *Point du Jour* (1934).

3 Mathematical objects, natural objects, primitive objects, found objects, irrational objects, ready-made objects, interpreted objects, incorporated objects, mobile objects. (Photographic reproductions in *Cahiers d'Art*, May 1936.)

BEYOND PAINTING

1 Vasari relates that Piero di Cosimo would at times remain plunged in contemplation of a wall on which sick people customarily spat; from the spots he formed equestrian battles, the most fantastic cities and the most magnificent landscapes ever seen; he did the same with clouds in the sky.

2 This very pretty term, destined to make its fortune because of its paradoxical content, I think should be approached with caution, because the notion 'paranoiac' is here employed in a sense which does not correspond to its medical meaning. I prefer Rimbaud's propositon: The poet makes himself a *seer* by a long, immense and reasoned *disorder of all the senses*.

3 With the exception of *The Virgin Punishing the Child Jesus* (1926), a manifesto-painting executed according to an idea of André Breton's.

Biographical Notes

ARAGON, Louis:
Born 1897 in Paris. Poet, essayist, novelist and journalist. Participant in the Dadaist movement. With Breton and Eluard one of the originators of surrealism and a regular contributor to Littérature and La Révolution Surréaliste. Joined the Communist Party in 1932 and is still a member.

ARP, Jean:
Born 1887 in Strasbourg. Poet, painter and sculptor. Met Max Ernst in Cologne in 1913. Founded the Dadaist movement with Tristan Tzara in Zurich in 1916 and collaborated with Max Ernst and Johannes Baargeld in the Cologne Dada group in 1919. Settled in Paris in 1922, joining the surrealist movement. Participated in the first surrealist group exhibition with Chirico, Ernst, Klee, Man Ray, Masson, Miró and Picasso at the Galerie Pierre in Paris (1925). His work is one of the moving forces of modern art. Now lives in Meudon (France) and Ascona (Switzerland).

ARTAUD, Antonin:
Born 1896 in Marseilles, died 1948 in Ivry near Paris. Poet, dramatic theorist, actor and director. Associated with surrealism from the beginning; contributor to La Révolution Surréaliste. In the search for the absolute and for ecstatic states his speculations carried him to the point of mental derangement.

BARON, Jacques:
Born 1905 in Paris. At the age of seventeen the 'Benjamin' of the surrealist poets. His collected volume, L'Allure poétique (1925), reminiscent of Apollinaire, was augmented in 1949 by Charbon de mer.

BASKINE, Maurice:
Born 1901 in Kharkov (Russia). Hermeticist and inventor of 'Fantasophy'. Member of the surrealist group from 1946 to 1951. Creates strange symbolic paintings and has prepared etchings for a deluxe edition of Breton's Arcane 17. Now lives in Paris.

BELLMER, Hans:
Born 1902 in Katowice (Poland). Painter. Created 'The Doll', a fetishist object capable of transformation. Constantly reinterprets his psycho-sexual inspirations in his drawings. Now lives in Paris.

BRAUNER, Victor:
Born 1903 in Pietra-Naemtz (Rumania). Painter and sculptor. Seeks a synthesis of personal obsessions and of symbolic images drawn from the collective unconscious. Now lives in Paris.

BRETON, André:
Born 1896 in Tinchebray (Orne). Poet and essayist, chief theoretician of surrealism. Played

an important role in the early Dadaist publications and manifestations in Paris. In 1921 broke with Tzara and the Paris Dadaists. Published the *Surrealist Manifesto* in 1924. Contributor to *La Révolution Surréaliste* (1924 to 1929). His work stimulated the younger generation on questions of contemporary art, literature, aesthetics and taste. The supreme incarnation of orthodox surrealism and the jealous guardian of its sanctuary.

BUÑUEL, Luis:
Born 1900 in Calanda (Teruel, Spain). Came to Paris in 1920 to study music. Joined the surrealists there in 1928 and directed the first films inspired by the theories and inclinations of the movement: *Un Chien Andalou* (1928), *L'Age d'Or* (1930), *Los Hurdes* (1932). Surrealism has also left a deep imprint on his other films. Now lives in Mexico.

CARRINGTON, Leonora:
Born in London. Writer and painter. Sensitive, tremorous and spontaneous work, completely in accord with the precepts of surrealism. Now lives in Mexico.

CHAR, René:
Born 1907 in L'Isle-sur-Sorgue (Vaucluse). Linked with the surrealists from 1930 to 1937. The music of his later poems, however, escapes all definition. Now lives in Paris.

CHIRICO, Giorgio de
Born 1888 in Volos (Greece). Painter of arcades, porticos, enigmas and metaphysical landscapes. With Carlo Carrà founded 'la Pittura Metafisica'. Discovered and encouraged by Apollinaire, praised by Breton and Eluard, he exerted a decisive influence on Ernst, Magritte and Tanguy. After 1917 his work lost its inspiration and faded into academicism. Now lives in Rome.

CREVEL, René:
Born 1900 in Paris, where he killed himself in 1935. Novelist, poet, essayist and pamphleteer. Among the first to join the surrealists. His early death prevented the full expression of his talent.

DALI, Salvador:
Born 1904 in Figueiras (Spain). Painter, poet and essayist. After futurist and cubist phases, entered the ranks of surrealism (1929) where his work was hailed with enthusiasm. Inventor of the 'paranoiac-critical' method. His painting employed academic technique to convey infantile obsessions. Collaborated with Buñuel in 1931. Later acquired a universal reputation as a result of constant self-advertisement and social scandals. Now lives in Cadaqués (Spain).

DAUMAL, René:
Born 1908 in the Ardennes, died 1944 in Paris. Poet and essayist. From his fifteenth year interested in the 'poètes maudits' and occultism. With his friends from the Lycée at Reims, R. Gilbert-Lecomte and R. Vailland, founded the movement and the review *Le Grand Jeu* (1928–31). See *Poésie noire, poésie blanche* (1954).

DELVAUX, Paul:
Born 1897 in Antheit (Belgium). After a trip through Italy and France discovered the surrealists. His paintings bring together the sixteenth-century Italian mannerists, the *Belle Rosine* of Antoine Wiertz and the locomotives of Chirico in an imaginary world peopled with sleep-walking nudes. Since 1935 he has participated in surrealist exhibitions without adhering directly to the movement. Now lives in Brussels.

DESNOS, Robert:
Born 1900 in Paris, died 1945 in a concentration camp at Theresienstadt (Czechoslovakia). One of the first poets to practise 'automatism' and one of the originators of surrealism. He left the movement in 1929.

DOMINGUEZ, Oscar:
Born 1906 in Tenerife (Canary Islands). Painter. Joined the surrealists in 1935. Inventor of 'decalcomania without a preconceived object'. Created 'surrealist objects' of a very personal character. Killed himself on New Year's Eve, 1958, in Paris.

DUCHAMP, Marcel:
Born 1887 in Blainville (Normandy). Brother of Jacques Villon and Raymond Duchamp-Villon. Travelled in 1913 to New York, where his *Nude Descending A Staircase* had a *succès de scandale* at the Armory Show. After World War I returned to Paris and collaborated with the surrealists until 1925. Rated by the surrealists as the key personality of modern art, his work began to exert a renewed fascination, especially on younger artists, in the late 1950s. Stopped painting in 1925 to devote himself to plastic or graphic signs and to word play designed to discredit the accepted notions of 'creation' in art. Questioned about his activities, he replies: 'I breathe'. Now lives in New York.

DUHAMEL, Marcel:
Born 1900 in Paris. Film actor and translator of American literature into French. Established in 1924 in the rue du Château the home of the Prévert-Tanguy group. Surrealist in behaviour, later founded *La Série Noire*, which he still directs. Now lives in Castelviaz (France).

DUPREY, Jean-Pierre:
Born 1929 in Rouen. Poet. Author of the book *Derrière son double*, for which Breton wrote an enthusiastic preface. After metal founding became a sculptor. Killed himself in 1959 in Paris.

ELUARD, Paul:
Born 1895 in Saint-Denis, died 1952 in Paris. With Breton and Aragon — first in *Littérature* and then in *La Révolution Surréaliste* — one of the founders of the surrealist movement and one of its greatest poets. Active with Aragon in the Resistance as a member of the Communist Party.

ENDE, Edgar:
Born 1901 in Hamburg-Altona. Painter. Studied in Munich where he has lived since 1931. Member of the German surrealists.

ERNST, Max:
Born 1891 in Brühl (Rhineland). In 1913 participated in the first German Autumn Salon in Berlin and met Arp at the Werkbund Exhibition in Cologne. Later joined Arp and Baargeld in founding the Cologne Dada group. In 1921 exhibited his collages for the first time in Paris where they exercised a decisive effect on nascent surrealism. With Breton, Desnos, Eluard, Péret, Crevel and Picabia undertook the first experiments in 'automatic writing'. As painter, sculptor and poet Ernst expresses the depth and diversity of surrealism. His visionary work was served by a number of processes of his own invention, principally *collage* and *frottage*. His passionate study of the premises of chance forms a link between the explorations attempted by the romantics and the more recent soundings of 'depth psychology'. Now lives in Paris and Seillans (Var).

FINI, Léonor:
Born in Argentina of a Trieste family. Painter of perverse enchantments. Realized the 'surrealizing' tendencies already implicit in the Pre-Raphaelites. Now lives in Paris.

GIACOMETTI, Alberto:
Born 1901 in Stampa (Grisons, Switzerland). First linked with the renegade surrealists (Bataille, Leiris, Limbour, Masson, Vitrac) in 1929. Between 1931 and 1934 moved closer to Breton and the 'official' surrealists; later broke away completely. Universally renowned for his sculpture, he created the finest sculptures and the most powerful 'objects' conceived by the surrealists. Now lives in Paris and Stampa.

GILBERT-LECOMTE, Roger:
Born 1907 in Reims, died 1943 in Paris. Painter, explorer of 'artificial paradises', co-founder of the surrealist review *Le Grand Jeu*. A profoundly metaphysical spirit, he lived in a dandyish indifference that was ineluctably strengthened by his natural talent. See his *Testament* (1955).

GORKY, Arshile:
Born 1904 in Hajotze Dzore (Turkish Armenia). Painter, with expressionist leanings. Joined Breton and Matta in New York, and was greatly influenced by them. His paintings are the expression of his passionate nature and tragic life, which he ended in 1948.

HENRY, Maurice:
Born 1907 in Cambrai. Painter and 'object'-maker. With Daumal, Gilbert-Lecomte and Sima, belonged to the para-surrealist movement that produced the review *Le Grand Jeu* (1928–31). Member of the surrealist group from 1932 to 1951. Introduced surrealism into comic drawing, where he made his name. His work as an artist is less well known because of his unreserved faithfulness to the chief aspirations of surrealism. Now lives in Paris.

HÉROLD, Jacques:
Born 1910 in Piatra (Rumania). In Paris from 1930, member of the surrealist movement intermittently from 1934. His painting displays mineral and crystalline structures and the interplay of knots and flames. One of the most fertile and powerful painters produced by the surrealist 'marvellous'.

HUGO, Valentine:
Born in Boulogne-sur-Mer. Painter. Creator of fairyland compositions and of portraits (Rimbaud, Breton, Eluard, Tzara, Crevel, etc.).

LABISSE, Félix:
Born 1905 in Douai. Painter and demonologist. Produced imagist fiction, dominated by love-fiction, on the stage and designed sets for plays, operas and ballets. Never belonged to the surrealist group, but recognized and acclaimed by Eluard, Desnos and Prévert. Now lives in Paris.

LAM, Wifredo:
Born 1902 in Sagua (Cuba). Painter. Linked with surrealism since 1938. Illustrated Breton's *Pleine marge* (1940). Painted the *Jungles* and the *Idoles* where primitive violence is contained by the intelligence and transposed into a refined poetics of nature and myth. Now lives in Italy.

LEIRIS, Michel:
Born 1901 in Paris. Friend of Max Jacob, Raymond Roussel and Picasso, from 1925

belonged to the surrealist group. Author of accounts of dreams and of a 'glossary' using euphonic analogies between words. The considerable position he holds today in French literature is due to his 'Phenomenology of Daily Life' which appeared in the series *La Règle du Jeu*. Now lives in Paris.

LE MARÉCHAL:

Born 1928 in Paris. Visionary painter praised by Breton in 1960. Pursues a slow and passionate course in a spirit of total independence. Now lives in Paris.

LIMBOUR, Georges:

Born 1901 in Le Havre (France). Friend of Masson, Leiris, Bataille and Queneau. Among the first surrealist poets in 1922, he left the movement in 1929, after contributing poetic prose of rare beauty in his *L'Illustre cheval blanc*. Now lives in Paris.

MAAR, Dora:

Born in Yugoslavia. Photographer and painter. After her brush with surrealism between 1935 and 1937 she took up a semi-monastic life devoted to mystical experience, and today remains isolated from the world in Ménerbes (Vaucluse).

MAGRITTE, René:

Born 1898 in Lessines (Belgium). Painter. From 1925 onwards his work revealed an intense preoccupation with fantasy. In 1927 acquaintance with the Paris surrealists strengthened his feeling for the unusual and drew him to surrealism, to which he remains faithful today. He proceeds by a simple and exact pictorial representation to wrench things away from their commonplace banality and restore their essential nature. With Ernst and Tanguy, one of the major representatives of surrealist art. Lives in Brussels.

MALKINE, Georges:

Born 1901 in Paris. Painter and poet. Among the first to participate in the work of the surrealist group in 1924. Sometime actor, proof-reader, and circus artist. Perfect example of surrealist behaviour. Now lives in the United States.

MARIE-LAURE:

Born in Paris. With her husband, the Vicomte Charles de Noailles, among the first to support and spread the gospel of surrealism. Her painting is in the fantastic vein. Now lives in Paris.

MASSON, André:

Born 1896 in Balagny (Oise). Friend of Miró in 1922, then of Limbour, Bataille and Leiris. One of the first painters to join the surrealist movement (1924), he was expelled in 1928. His 'automatic drawings' appeared in almost every issue of *La Révolution Surréaliste*. Later entered into fruitful explorations of an almost metaphysical quality: *Mythologie de l'être, Sacrifices*, etc. Now lives in Paris.

MATTA, Roberto:

Born 1911 in Santiago (Chile). Taken up by Breton and the surrealists in 1938. One of the movement's leading innovators, especially between 1942 and 1948. Afterwards gave a revolutionary political meaning to his work. Now lives in Paris.

MESENS, E. L. T.:

Born 1903 in Brussels. Composer, poet and painter of collages. With Magritte, one of the leading exponents of Dadaism and surrealism in Belgium. His work, as much written as plastic, possesses pleasing qualities of refinement and humour. Now lives in London.

MIRÓ, Joan:
Born 1893 in Montroig (Spain). Met Picabia in Barcelona in 1917. Associated with the Paris surrealists, in 1924 signed the *Surrealist Manifesto* and in 1925 participated in the first surrealist group exhibition in the Galerie Pierre. Mirós paintings are concerned with the enigmatic status of man in an enigmatic world, as blots and splashes give rise to forms and these in turn give rise to a new reality. Now lives in Palma de Majorca.

NOUGÉ, Paul:
Poet and essayist. With Magritte and Mesens one of the leading Belgian surrealists. Contributor to *La Révolution Surréaliste* and the Belgian reviews *Distances, Correspondances, Marie, Variétés, Documentes 34* and *Les Lèvres nues.*

OELZE, Richard:
Born 1900 in Magdeburg (Germany). Painter. Worked at the Bauhaus in Weimar (1921–26), with the surrealists in Paris (1932) and in Switzerland before the war; returned to Germany after the war. Creates vegetable landscapes with anthropomorphic figures. With Max Ernst's his work is the greatest expression of surrealism that Germany produced. Now lives in Worpswede.

OPPENHEIM, Meret:
Born in Berlin. Painter and 'object'-maker. Member of the surrealist group. Her uninhibited behaviour and inventive grace made her the perfect example, both in her life and in her art, of the surrealist woman. Now lives in Switzerland.

PAALEN, Wolfgang:
Born 1907 in Vienna, died 1959 in Mexico. Painter. Studied in France, Germany and Italy. Lived in Paris until 1939, afterwards in Mexico. After an abstract phase, adhered to the surrealist movement in 1930; left the movement in 1941. Inventor of the 'fumage' technique, blackening the canvas with a candle-flame.

PENROSE, Roland:
Born 1900 in London. Painter. Since 1926 a close friend of Picasso, Eluard and Ernst. Introduced surrealism into Britain. Paints collages with a very personal quality. Now lives in London.

PÉRET, Benjamin:
Born 1899 in Rézé near Nantes, died 1959 in Paris. One of the greatest poets of the surrealist movement, to which he remained unconditionally faithful throughout his life. His magical, aggressive or gentle work is a continuous outpouring of unusual images assembled from everyday words. It met surrealist requirements fully, as did also his militant and revolutionary radicalism. In 1929 he began with Pierre Naville the surrealist review *La Révolution Surréaliste.* Edited an *Anthologie de l'amour sublime* (1956).

PICABIA, Francis:
Born 1879 in Paris, died there 1953. Poet and painter. Exhibited at the New York Armory Show in 1913. Then linked with Tzara and Arp, the animators of Dadaism. After 1919 returned to Paris, where he became friends with the surrealists. A forerunner of the principal trends of modern art, without ever being attached to a school or style. Also an accomplished dandy, full of surprises. His work influences an increasing number of artists and poets.

PICASSO, Pablo:
Born 1881 in Málaga (Spain). Placed at the

summit of artistic achievement by Breton in *Surrealism and Painting*, he was accepted by the surrealists as one of them until 1938. Has sometimes participated in reunions of 'the group'. Now lives in Les Mougins.

PRÉVERT, Jacques:

Born 1900 in Paris. Poet. With brother Pierre and friends Duhamel and Tanguy, joined the surrealist ranks in 1925 and left in 1929. The spontaneity of his language and his acute sense of the marvellous in daily life make his poetry among the richest of the period. Introduced surrealism into popular songs and into the films which he wrote: *Drôle de drame, Les Enfants du paradis, Les Visiteurs du soir,* etc. Now lives in Paris.

PRÉVERT, Pierre:

Born 1906 in Paris. Brother of Jacques Prévert. Author of films in which surrealism rises from the meeting of the marvellous and humour: *L'Affaire est dans le sac, Adieu Léonard, Paris la belle, Le grand Claus et le petit Claus.* Now lives in Paris.

QUENEAU, Raymond:

Born 1903 in Le Havre. Poet, novelist, mathematician, philosopher and philologist. His encyclopædic work was not yet begun during his adherence to surrealism (1924--29). In 1928 one of the most enthusiastic members of the 'rue du Château' group (with Jacques Prévert, Tanguy, Duhamel). Now lives in Paris.

RAY, Man:

Born 1890 in Philadelphia. Painter, inventor of 'objects', photographer, 'memorialist'. The precursor of Dada and surrealism in the U.S. Associated with Picabia and Duchamp in New York during World War I. Went to Paris in 1921 and entered the *Littérature* group (Breton, Rigaut, Eluard, etc.). Creator of 'Rayograms', photographs taken without a lens. His work is among the most fertile of modern art, and his photographic archives will yield an incomparable record of the literature, art and personalities of the period. Now lives in Paris.

RIGAUT, Jaques:

Born 1899 in Paris, where he killed himself in 1929. Belonged to the *Littérature* group and collaborated in the production of *La Révolution Surréaliste*. Incarnates the cynical and bitter disillusion, the despair disguised in provocation, of many young men after 1918 for whom dandyism offered no solution.

SCHRÖDER-SONNENSTERN, Friedrich:

Born 1899 in Berlin. Began painting in 1956, after having led a tormented life. His spontaneously surrealistic work was greeted with fervour by Breton and others. Now lives in Berlin.

SCUTENAIRE, Louis:

Born 1905 in Ollignies (Belgium). Poet and essayist. From 1926 member of the Belgian surrealist group founded by Magritte, Mesens, Nougé and Goemans. His wife writes under the name of Irène Hamoir.

SIMA, Joseph:

Born 1891 in Prague. Artistic director of the para-surrealist review *Le Grand Jeu* (1928–31). His painting, born of meditation and mystical inspiration, expresses the illumination of the 'interior life'. Now lives in Paris.

SOUPAULT, Philippe:

Born 1897 in Chaville (Seine-et-Oise). Poet. Participated in the Dada movement with members of the *Littérature* group, and in the

surrealist movement, from which he was excluded in 1929. In collaboration with Breton, produced the first collection of 'automatic writing': *Les Champs magnétiques*. Now lives in Paris.

SVANBERG, Max-Walter:
Born 1912 in Malmö (Sweden). Painter. Came to surrealism about 1959. Creator of imaginary and fairy worlds not unlike those of the symbolist movement. Now lives in Sweden.

TANGUY, Yves:
Born 1900 in Paris, died 1955 in Woodbury, Connecticut. Painter. Linked with Jacques Prévert after 1921, joined the surrealist group in 1925. Emigrated to the U.S. in 1939 and became an American citizen. In his depiction of an imaginary world drawn from the deep springs of the unconscious and of childhood, he provided one of the primary sources of surrealist art.

TANNING, Dorothea:
Born in Galesburg, Illinois. Painter. Moved from realistic depiction presenting a dream-like vision to the discovery of moving spaces without the landmarks of horizon or earth, to the theatre of sensual and untamed epiphanies. Now lives in Paris and Seillans (Var).

TOYEN, Marie Cernisova:
Painter and poet. Since her entry into the surrealist movement in 1936 unconditionally faithful to Breton and the group authority. Now lives in Paris.

TZARA, Tristan:
Born 1896 in Rumania, died 1963 in Paris. Poet. One of the founders and promoters of Dada in Zurich in 1916. Settled in Paris in 1919 where three years later he joined the poets of the *Littérature* group, the founding fathers of surrealism. Kept apart from the surrealist movement until 1928, later moved away during the Resistance to join the Communist Party with Eluard and Aragon.

UBAC, Raoul:
Born 1910 in Malmédy (Belgium). Painter and experimental photographer. Adhered to the Belgian surrealist movement (1934–38). Published his interesting *Solarisations* in the review *Minotaure*. In 1942 he turned away from surrealism, becoming increasingly involved in abstractionism. Prefers to work in slate. Now lives in Paris.

VACHÉ, Jacques:
Born 1896 in Paris, died 1919 in Nantes. Meeting him in military hospital in 1916 was a turning point in Breton's orientation, who described the nature of Vaché's influence in *Les Pas perdus*. After his death he became a surrealist culture hero.

VITRAC, Roger:
Born 1899 in Pinsac (Lot), died in Paris. Poet and playwright. Connected with *Littérature* from 1922. Introduced surrealist humour into the theatre with *Victor ou les enfants au pouvoir*, *Le Coup de Trafalgar*, *Le Loup-garou* and *Le Sabre de mon père*.

Chronology

1916 — Meeting of André Breton and Jacques Vaché
1917 — Meeting of André Breton, Louis Aragon and Philippe Soupault
1918 — Meeting of André Breton and Paul Eluard
1919 — Breton and Soupault discover the possibilities of 'automatic writing'
 — Tristan Tzara arrives in Paris
 — Foundation of the magazine *Littérature*
 — Jacques Vaché commits suicide
1920 — Benjamin Péret joins the *Littérature* group
1921 — Breton visits Sigmund Freud in Vienna
1922 — Jacques Baron, René Crevel, Robert Desnos, Georges Limbour and Roger Vitrac join
 the *Littérature* group, who were then calling themselves surrealists
 — 'Sleep' experiments
 — Man Ray and Max Ernst arrive in Paris
1923 — André Masson paints *Les Quatre éléments* and is taken up by the surrealists
 — Tzara quarrels with Breton
1924 — Joan Miró paints *Terre labourée* and *Le Carnaval d'Arlequin*, and joins the surrealists
 along with Antonin Artaud, Giorgio de Chirico, Francis Gérard, Mathias Lübeck,
 Georges Malkine, Max Morise, Pierre Naville, Raymond Queneau and others
 — Publication of Breton's first Surrealist Manifesto
 — Foundation of the magazine *La Révolution Surréaliste*
 — Opening of the Bureau of Surrealist Enquiries
 — Publication of the pamphlet against the late Anatole France
 — A surrealist group comes into being in Yugoslavia under the leadership of Marco
 Ristitch
1925 — Pierre Brasseur, Michel Leiris, Jacques Prévert, Yves Tanguy and others join the
 surrealists
 — 'Declaration of 27 January 1925' signed by twenty-six surrealists
 — Pamphlet against Paul Claudel
 — Anti-patriotic manifestation and brawl in the 'Closerie des Lilas'
 — First surrealist group exhibition in the Galerie Pierre, Paris
1926 — Invention of the game 'Le Cadavre Exquis'
 — Film *Emak Bakia* by Man Ray
 — Miró and Max Ernst are expelled and then reinstated by the surrealists
 — Foundation of the Belgian surrealist group (Camille Goemans, Marcel Lecomte, René
 Magritte, E.L.T. Mesens and Paul Nougé)
1927 — André Breton and a few others join the Communist Party and soon leave it
 — Artaud and Soupault break away from the surrealists
 — Opening of the 'Galerie surréaliste' in Paris
1928 — Breton publishes *Nadja* and *Le Surréalisme et la Peinture*
 — Film *L'Etoile de Mer* by Man Ray and Robert Desnos
 — Film *Un Chien Andalou* by Luis Buñuel
 — Partial agreement between the surrealists and the group 'Le Grand Jeu' (Monny de

Boully, René Daumal, Roger Gilbert-Lecomte, Arthur Harfaux, Maurice Henry, Joseph Sima, Roger Vaillant)

1929 – Baron, Limbour, Masson, Naville, Prévert, Queneau, Vitrac and several others quarrel with the surrealists; they are replaced by Buñuel, René Char, Salvador Dali and Tzara, who has been reconciled with Breton
 – Foundation of the Czechoslovak surrealist group (Vitezlav Nezval, Jindrich Styrsky, Karel Teig, Toyen)
 – Jacques Rigaut commits suicide

1930 – Breton publishes the second Surrealist Manifesto
 – Foundation of the magazine *Le Surréalisme au Service de la Révolution*
 – Desnos breaks with the surrealists and joins other renegades who publish a pamphlet against Breton
 – The surrealists protest against the opening of the 'Bar Maldoror' in Montparnasse; René Char gets a knife wound in the process
 – Two members of the group, Jean Caupenne and Georges Sadoul, insult an officer of Saint-Cyrien – the former agrees to make a public apology and therefore excludes himself from surrealism; the latter is sentenced to three months' imprisonment
 – Performance of Buñuel's new film, *L'Age d'Or:* a fascist manifestation by groups of the extreme Right destroys the cinema and the pictures on exhibit there
 – The creation of 'objets surréalistes à fonctionnement symbolique'

1931 – Creation of countless surrealist objects
 – Alberto Giacometti joins the movement
 – The surrealists join the recently-founded 'Association des Ecrivains et Artistes Révolutionnaires' (A.E.A.R.)

1932 – Aragon becomes a member of the Communist Party and breaks with the surrealists
 – Victor Brauner, Roger Caillois, Arthur Harfaux, Maurice Henry, Georges Hugnet, Marcel Jean, Meret Oppenheim, Henri Pastoureau, Gui Rosey and others join the surrealist movement, as do a group of writers on the Antilles including Jules Monnerot

1933 – Breton is expelled from the A.E.A.R. because he does not want to submit to the discipline of self-criticism; his friends declare their solidarity with him and leave the group under vigorous protest
 – Foundation of the glossy magazine *Minotaure*
 – Kandinsky is guest of honour of the surrealists, who give a show in the 'Salon des Surindépendants'

1934 – Foundation of the surrealist group in Egypt under the leadership of Georges Henein
 – The surrealists pay homage to Violette Nozieres, condemned to death for poisoning a father who had ill-treated her
 – Jacques Hérold, Gisèle Prassinos (fourteen years old), Dora Maar and Leo Malet join the group
 – Richard Oelze works in Paris and comes into contact with the surrealists

1935 – Wolfgang Paalen and Hans Bellmer, who comes to Paris from Berlin accompanied by his *Poupée,* join the group
 – Picasso, who regularly visits the surrealists, writes his first poems
 – International surrealist exhibitions in Copenhagen and Tenerife
 – Breton boxes the ears of Ilya Ehrenburg, the Russian author, for insulting the surrealists; as a result, Breton loses his position in the 'Congrès Mondial des Ecrivains pour la Défense de la Culture'
 – Publication of the first *Bulletin International du Surréalisme* in Prague
 – Oscar Dominguez, Pierre Mabille and J.-B. Brunius join the group
 – René Crevel commits suicide
 – Publication of the second *Bulletin International du Surréalisme* in Brussels
 – The surrealists take part in the 'Contre-Attaque' movement, an anti-fascist 'Fighting Union of Revolutionary Intellectuals'

1936 – Dominguez invents 'decalcomania without a preconceived object'
 – First surrealist exhibition of objects at the Galerie Ch. Ratton, Paris
 – Foundation of a Japanese surrealist newspaper in Tokyo under the direction of Yamanaka

- International surrealist exhibition in London in which the following English surrealists take part: Eileen Agar, Hughes Sykes Davies, David Gascoyne, Humphrey Jennings, Henry Moore, Paul Nash and Herbert Read; publication of the third *Bulletin International*
1937 – Artaud is interned in a mental hospital
 – Kurt Seligmann joins the surrealist movement
 – Paalen invents the 'fumage' technique
 – Breton opens the surrealist 'Galerie Gradiva'
1938 – International surrealist exhibition at the Galerie des Beaux-Arts, Paris
 – Matta joins the surrealists
 – Roland Penrose and E.L.T. Mesens found the *London Bulletin*
 – Breton, together with Trotsky and Diego Rivera, publishes the manifesto *Pour un Art révolutionnaire indépendant* in Mexico
 – International surrealist exhibition in Amsterdam
 – Eluard breaks with the surrealists to join the Communist Party
 – Pamphlet *Ni de votre Guerre ni de votre Paix* published
 – The surrealists break with Dali
1939 – Publication of *Cle*, bulletin of the 'Federation International de l'Art Révolutionnaire Indépendant'
 – Tanguy and Matta go to the U.S.A., Paalen to Mexico
1940 – Wifredo Lam meets the surrealists
 – International surrealist exhibition in Mexico
1941 – Breton, Ernst and Masson emigrate to the U.S.A., Péret joins Paalen in Mexico
 – Foundation of the magazine *Tropiques* by Aimé Cesaire on Martinique
 – A surrealist group appears in Bucharest (Luca, Trost *et al*)
 – Reduced surrealist activity in Paris (J. F. Chabrun, N. Arnaud, Malet, Ubac, Eluard, Dominguez, M. Henry, Hugnet and others)
1942 – Foundation of the magazines *VVV* in New York and *Dyn* in Mexico
 – Meeting of Breton, Patrick Waldberg and Robert Lebel in New York
 – Meeting of Max Ernst and Dorothea Tanning in New York
 – International surrealist exhibition in New York
1943 – In Brussels Nougé publishes *René Magritte ou les Images défendues*
 – Seligmann, also in the U.S.A., breaks with the surrealists
 – Death of Roger Gilbert-Lecomte
1944 – Private reading in Paris of Picasso's *Le Désir attrapé par la queue*
 – In New York Breton enthusiastically endorses the paintings of Arshile Gorky
 – Death of René Daumal
 – Mathias Lübeck is taken hostage by the Germans and shot
1945 – In Mexico Péret publishes *Deshonneur des poètes*, a pamphlet against the 'involved' poems of Eluard, Aragon and others which were distributed by the underground movement in France during the German occupation
 – Students in Port-au-Prince, Haiti, demonstrate after a lecture by Breton, provoking a rebellion and the fall of the government
 – Desnos dies in the Teresienstadt concentration camp
1946 – Breton back in Paris
 – Artaud released from the mental hospital
1947 – Publication of the manifesto *Rupture inaugurale* addressed to the French Communist Party, expressing the decisive mistrust of the forty-nine signatories
 – International surrealist exhibition at the Galerie Maeght, Paris
 – Breton protests during a lecture by Tzara against surrealism
1948 – Péret returns to Paris
 – Foundation of *Néon*, a surrealist magazine under the editorship of Jindrich Heisler
 – During a sitting of the U. N. Garry Davis causes a surrealistic scandal by suggesting the establishment of a world government
 – Matta and Brauner are expelled from the group
 – International surrealist exhibition in Prague and Santiago, Chile
 – Anti-religious collective manifesto *A la 'niche, les glapisseurs de dieu'* signed by fifty-

two surrealists of which fifteen were in the pre-War group
- Death of Artaud
- Suicide of Gorky in the U.S.A.
1949 - Jean Pierre Duprey joins the movement
- Death of J. Caceres, leader of the surrealist group in Chile
1950 - Publication of *L'Almanach surréaliste du demi-siècle*
- André Pieyre de Mandiargues joins the surrealists
- Publication of *La Littérature a l'Estomac*
- Julien Gracq publishes pamphlet against literary prizes
- Dali makes known his conversion to Catholicism
1951 - Publication of *Surrealistische Publikationen* in Vienna/Klagenfurt under the editorship of Max Hölzer
- The poet Octavio Paz publishes *Aguila o sol* in Mexico
- In protest against the inclusion of the practising Catholic Michel Carrouges in the surrealist movement, A. Acker, M. Baskine, M. Henry, J. Hérold, M. Jean, R. Lebel, H. Pastoureau, Seigle and P. Waldberg leave the group
- Breton breaks with Carrouges
- Pieyre de Mandiargues is offered the 'Critics Prize' and accepts it
- Julien Gracq is given the 'Prix Goncourt' and sends it back
- Death of Roger Vitrac
1952 - Return of Wolfgang Paalen to Paris
- Surrealists work on *Libertaire,* the newspaper of the Anarchist Federation
- Exhibition of surrealist painting in Saarbrucken
- Breton, after touching a painting in a prehistoric cave with his finger, is taken to court for damaging a public monument
- Death of Pierre Mabille
- Death of Paul Eluard
1953 - Yves Tanguy expelled by the surrealists
- Invention of the game 'L'Un dans l'autre'
- Death of Jindrich Heisler
1954 - The surrealists take a lively interest in Gallic art
- Joyce Mansour publishes *Cris* and joins the group
- Surrealists come out in support of the anti-colonial revolution in Algeria
- Death of Picabia
1955 - Arp, Ernst and Miró accept the prize of the Venice Biennale; only Ernst is expelled from the group
- Death of Tanguy
1956 - Pamphlet *Hongrie, Soleil levant* published in honour of the rising in Budapest
1957 - The 'Cartes d'analogie' collective experiment
1958 - Pamphlet *Demasquez les Physiciens, videz les Laboratoires* published against atomic research
- Suicide of Dominguez
1959 - Breton reconciled with Matta and Brauner
- Death of Péret
- Suicide of Duprey
- Suicide of Paalen
1960 - International surrealist exhibition at the Galerie D. Cordier, Paris
- Protest against Duchamp's decision to accept a recent picture by Dali in an international surrealist exhibition in New York
- Breton becomes a member of the committee to select a 'Prince des Poètes'
1961 - Suicide of Kay Sage, surrealist painter and wife of Tanguy
1962 - Suicide of Kurt Seligmann
1963 - Death of Tristan Tzara
1964 - Big exhibition in the Galerie Charpentier, Paris - 'Le Surréalisme: Sources, Histoire, Affinités'. Breton, who was not asked to organize the exhibition, protests against it
1965 - Big retrospective travelling exhibition in Germany of the work of Richard Oelze

Selected Bibliography

I General

ALQUIE, Ferdinand: *Philosophie du Surréalisme*. Paris (Flammarion), 1955.
BARR, Alfred H., jr.: *Fantastic Art, Dada, Surrealism*, with essays by Georges Hugnet. New York (Museum of Modern Art), 1936.
BRETON, André: *Qu'est-ce que le Surréalisme?* Brussels (Henriques), 1934. Trans. David Gascoyne: *What Is Surrealism?* London (Faber), 1936.
— *Essais et Témoignages*. Neuchâtel (A la Baconnière), 1950.
BRUNIUS, Jacques: *En marge du Cinéma français*. Paris (Arcanes), 1954.
CARROUGES, Michel: *André Breton et les données fondamentales du Surréalisme*. Paris (Gallimard), 1934.
HUGNET, Georges: *Petite Anthologie poétique du Surréalisme*. Paris (Jeanne Bucher), 1934.
JEAN, Marcel: *Histoire de la Peinture surréaliste*. Paris (Seuil), 1959. Cologne (DuMont Schauberg), 1960. Trans. Simon Watson Taylor: *History of Surrealist Painting*. London (Weidenfeld & Nicolson), 1962.
— *Genèse de la Pensée Moderne*. In collaboration with Arpad Mezei. Paris (Correa), 1952.
LEVY, Julien: *Surrealism*. New York, 1936.
MABILLE, Pierre: *Le Miroir de Merveilleux*. Paris (Sagittaire), 1940.
MANGEOT, Guy: *Histoire du Surréalisme*. Brussels (Henriques), 1934.

MONNEROT, Jules: *La Poésie Moderne et le Sacré*. Paris (Gallimard), 1945.
NADEAU, Maurice: *Histoire du Surréalisme*. Paris (Seuil), new edn., 1964.
READ, Herbert (ed.): *Surrealism*. London (Faber), 1936.
WALDBERG, Patrick: *Le Surréalisme*. Geneva (Skira), 1962.

II Biographies and Monographs

ARP, Jean: *On My Way*. New York (Wittenborn), 1948.
BELLMER, Hans: *La Poupée*. Paris (G.L.M.), 1936. Berlin (Gerhardt), 1962.
— *Anatomie de l'Image*. Paris (Terrain Vague), 1957.
BRETON, André: *Toyen*. In collaboration with Jindrich Heisler and Benjamin Péret. Paris (Sokelova), 1953.
BRION, Marcel: *Léonor Fini et son œuvre*. Paris (Pauvert), 1955.
BUTOR, Michel: *Hérold*. Paris (Musée de Poche), 1964.
CRASTRE, Victor: *André Breton*. Paris (Arcanes), 1952.
CREVEL, René: *Dali ou l'anti-obscuratisme*. Paris (Surréalistes), 1935.
— *Paul Klee*. Paris (Gallimard), 1930.
DALI, Salvador: *La Conquête de l'Irrationnel*. Paris (Surréalistes), 1935.
DESNOS, Robert: *Labisse*. Paris (Sequana), 1945.

La Vie secrete de Salvador Dali. Paris (Table Ronde), 1952.

DUPIN, Jacques: *Alberto Giacometti*. Paris (Maeght), 1962.

Joan Miró. Paris (Maeght), 1961. Cologne (DuMont Schauberg), 1961. London (Thames & Hudson), 1962.

GRACQ, Julien: *André Breton*. Paris (Corti), 1948.

HÉROLD, Jacques: *Maltraité de Peinture*. Paris (Falaise), 1957. Wuppertal (Galerie Parnass), 1960.

JOUFFROY, Alain: *Victor Brauner*. Paris (Musée de Poche), 1959.

JUIN, Herbert: *André Masson*. Paris (Musée de Poche), 1963.

KYROU, Ado: *Luis Buñuel*. Paris (Seghers), 1962.

LABISSE, Félix: *Le Sorcier des Familles*. Paris, 1957.

LEBEL, Robert: *Sur Marcel Duchamp*. Paris (Trianon Press), 1959. Cologne (DuMont Schauberg), 1960.

MASSON, André: *Entretiens*. With G. Charbonnier. Paris (Julliard), 1963.

RAY, Man: *Self-portrait*. Boston-Toronto (Little, Brown), 1963. Paris (Laffont), 1964.

SANOUILLET, Michel: *Francis Picabia*. Paris (Ed. du Temps), 1964.

SCUTENAIRE, Louis: *René Magritte*. Brussels (Librairie Sélection), 1943.

SEITZ, William and LEVY, Julien: *Arshile Gorky*. New York (Museum of Modern Art), 1962.

SOBY, James Thrall: *The Early Chirico*. New York (Dodd, Mead), 1941.

Yves Tanguy. New York (Museum of Modern Art), 1955.

WALDBERG, Patrick: *Max Ernst*. Paris (Pauvert), 1958.

Mains et Merveilles. On Arp, Duchamp, Ernst, Hérold, Labisse, Matta, Picabia, Man Ray *et al*. Paris (Mercure de France), 1961.

René Magritte. Brussels (De Rache), 1965.

III Surrealist Texts

ARAGON, Louis: *Le Libertinage*. Paris (Gallimard), 1924.

Le Paysan de Paris. Paris (Gallimard), 1926.

Traité du Style. Paris (Gallimard), 1928.

La Peinture au Defí. Paris (Galerie Goemans), 1930.

ARP, Jean: *La Siège de l'Air*. Paris (Vrille), 1946.

ARTAUD, Antonin: *Oeuvres complètes*. (5 vols.). Paris (Gallimard), 1956.

BARON, Jacques: *L'Allure poétique*. Paris (Gallimard), 1925.

BRETON, André: *Nadja*. Paris (Gallimard), 1928.

Le Révolver a Cheveux blancs. Paris (Cahiers Libres), 1932.

Les Vases communicants. Paris (Cahiers Libres), 1932.

L'Amour fou. Paris (Gallimard), 1937.

Surrealism and Painting. New York (Brentano), 1945.

Arcane 17. Paris (Sagittaire), 1947.

Les Manifestes du Surréalisme. Paris (Pauvert), new edn., 1962.

— and Philippe Soupault: *Les Champs magnétiques*. Paris (Au Sans-Pareil), 1920.

— and Paul Eluard: *L'Immaculée Conception*. Paris (Surréalistes), 1930.

CARRINGTON, Leonora: *La Dame ovale*. Paris (G.L.M.), 1939.

CESAIRE, Aimé: *Les Armes miraculeuses*. Paris (Gallimard), 1946.

CHAR, René: *Le Marteau sans Maître*. Paris (Surréalistes), 1934.

CHIRICO, Giorgio de: *Hebdemeros*. Paris (Garrefour), 1929.

CREVEL, René: *L'Esprit contre la raison*. Marseille (Cahiers du Sud), 1928.

Êtes-vous fous? Paris (Gallimard), 1929.

Les Pieds dans le Plat. Paris (Sagittaire), 1933.

DALI, Salvador: *Baboue*. Paris (Cahiers Libres), 1932.

DESNOS, Robert: *Deuil pour Deuil.* Paris (Kra), 1925.
La Liberté ou l'Amour. Paris (Sagittaire), 1927.
Domaine public. Paris (Gallimard), 1953.
DUCHAMP, Marcel: *Marchand du Sel.* Paris (Terrain Vague), 1958.
ELUARD, Paul: *Capitale de la Douleur.* Paris (Gallimard), 1926.
L'Amour la Poésie. Paris (Gallimard), 1929.
Donner à Voir. Paris (Gallimard), 1939.
Les Malheurs des Immortels. Paris (Librairie Six), 1922. Cologne (Der Spiegel), 1959.
– and Max Ernst: *Répétitions.* Paris (Au Sans-Pareil), 1922.
ERNST, Max: *Une Semaine de Bonté.* Paris (Pauvert), new edn., 1964.
FERRY, Jean: *Le Mécanicien.* Paris (Gallimard), 1953.
GRACQ, Julien: *Au Château d'Argol.* Paris (Corti) 1938.
LECOMTE, Marcel: *L'Accent du secret.* Paris (Gallimard), 1944.
LEIRIS, Michel: *Le Point Cardinal.* Paris (Sagittaire), 1927.
L'Age d'Homme. Paris (Gallimard), 1939.
Nuits sans Nuit. Paris (Gallimard), 1961.
LUBECK, Mathias: *Poèmes et Proses de 'l'Oeuf dur'.* Paris (Julliard), 1963.
LUCA, Ghérasim: *Le Vampire passif.* Bucharest (Ed. de l'Oubli), 1943.
MESENS, E. L. T.: *Alphabet Sourd-Aveugle.* Brussels (Flamel), 1933.
Poèmes. Paris (Terrain Vague), 1959.
NOUGÉ, Paul: *Histoire de ne pas rire.* Brussels (Lèvres nues), 1962.
PÉRET, Benjamin: *Choix de Textes.* Paris (Seghers), 1961.
PEYRE de MANDIARGUES, André: *Les Incongruités monumentales.* Paris (Laffont), 1948.
PICASSO, Pablo: *Le Désir attrapé par la Queue.* Paris (Gallimard), 1945.

PRASSINOS, Gisèle: *La Sauterelle arthritique.* Paris (G. L. M.), 1939.
PRÉVERT, Jacques: *Paroles.* Paris (Point du Jour), 1946.
QUENEAU, Raymond: *Si tu t'imagines.* Paris (Gallimard), 1952.
RIGAUT, Jacques: *Papiers posthumes.* Paris, 1934.
ROSEY, Guy: *La Guerre de 34 ans.* Paris (Cahiers Libres), 1932.
SCUTENAIRE, Louis: *Mes Inscriptions.* Paris (Gallimard)
SOUPAULT, Philippe: *Poésies complètes.* Paris (G. L. M.), 1937.
TZARA, Tristan: *L'Homme approximatif.* Paris (Fourcade), 1930.
L'Antitête. Paris (Cahiers Libres), 1933.
Grains et Issues. Paris (Denoël & Steele), 1933.
VACHÉ, Jacques: *Lettres de Guerre.* Paris (Gallimard), 1919.
VITRAC, Roger: *Connaissance de la Mort.* Paris (Gallimard), 1926.
Humoristiques. Paris (Gallimard), 1927.
Théâtre (2 vols.). Paris (Gallimard), 1946.

IV Periodicals

Bief. Paris, 1958–60.
La Brèche. Paris, 1961.
Contemporary Poetry and Prose (London), No. 2, June 1936, 'Double Surrealist Number'.
Littérature. Paris, 1919–24.
Médium. Paris, 1954–55.
Minotaure. Paris, 1933–38.
La Revolution Surréaliste. Paris, 1924–29.
Le Surréalisme au service de la Revolution. Paris, 1930–33.
Le Surréalisme, même. Paris, 1956–57.
This Quarter (Paris), Sept. 1932.
VVV. New York, 1942–44.

List of Illustrations

Colour

I André Masson, *Gradiva*, 1939. Oil on canvas, 100×73 cm. Galerie Louise Leiris, Paris

II Joan Miró, *Person Throwing a Stone at a Bird*, 1926. Oil on canvas, 73×92 cm. The Museum of Modern Art, New York

III Salvador Dali, *The Dismal Sport*, 1932. Oil and collage, 46×38 cm. Private collection

IV Yves Tanguy, *The Furnished Times*, 1939. Oil on canvas. Collection James Thrall Soby, New Canaan, Connecticut

V Max Ernst, *Dove*, 1928. Painting and collage (frame made by the artist), 57×52 cm. Formerly owned by Félix Fénéon

VI René Magritte, *Presence of Mind*, 1958. Oil on canvas, 116×89 cm. Private collection

VII Matta, *To Give Painless Light*, 1960. Oil on canvas, 300×202 cm. Private collection

VIII Jacques Hérold, *The Initiator*, 1959. Oil on canvas, 55×38 cm. Collection Budin, Paris

Black and White

1 *The Awakening of the Child's Mind:* retouched photograph of the painting by Giorgio de Chirico, *The Child's Mind,* which appeared in the *Almanach Surréaliste du demi-siècle*, Paris 1950

2 The *Littérature* group in 1922. Standing, left to right: Paul Chadourne, Tristan Tzara, Philippe Soupault, Serge Charchoune. Seated, left to right: Man Ray (collage), Paul Eluard, Jacques Rigaut, Mick Soupault, Georges Ribemont-Dessaignes

3 The *Littérature* group in 1922: André Breton, Paul Eluard, Tristan Tzara, Benjamin Péret

4 Georges Malkine, André Masson, André Breton, Max Morise and Georges Neveux in Thorenc (Alpes Maritimes), 1923

5 A gathering of surrealists, 1924. Standing, left to right. Jacques Baron, Raymond Queneau, Pierre Naville, André Breton, J.-A. Boiffard, Giorgio de Chirico, Roger Vitrac, Paul Eluard,

92 Matta, *Doubt's Pilgrim,* 1946. Oil on canvas, 219 × 366 cm.

93 Wolfgang Paalen, *Medusan Landscape,* 1937. Oil on canvas, 130 × 162 cm. Collection Lefebvre-Foynet, Paris

94 Matta, *Intervision,* 1955. Oil on canvas

95 *Intervision* by Victor Brauner in collaboration with Matta, 1955. Oil on canvas. Private collection

96 Oscar Domiguez, *The Huntsman,* 1934. Oil

97 Toyen, *The Feasts of Silk,* 1962. Oil on canvas, 100 × 65 cm. Collection Patrick Waldberg, Paris

98 Wifredo Lam, *Idol,* 1944. Oil on canvas. Collection Galerie Pierre

99 Richard Oelze, *Expectation,* 1935/36. Oil on canvas, 81.5 × 100.5 cm. The Museum of Modern Art, New York

100 Richard Oelze, *The Pillar,* 1953. Pencil on paper, 25.3 × 42.3 cm. Artist's collection

101 Dorothea Tanning, *Two Words,* 1963. Oil on canvas

102 Dorothea Tanning, *Palaestra,* 1947. Collection W.N. Copley, New York

103 Félix Labisse, *The Future Revealed,* 1955. Oil on convas

104 Marie-Laure, *The Lions' Thirst,* 1962

105 Max Walter Svanberg, *Kiss of the Dream-Woman,* 1959. Oil on canvas. Collection Raymond Cordier, Paris

106 Le Maréchal, *The Monster of State,* 1958. Oil on wood

107 Arshile Gorky, *Water of the Flowery Mill,* 1944. Oil on canvas, 107 × 124 cm. The Museum of Modern Art, New York

108 Victor Brauner, *Untitled,* 1937. Oil

109 Edgar Ende, *The End,* 1931. Oil, 59 × 71 cm. Collection Jean Laffont, Nîmes

110 René Magritte, *Loving Perspective,* 1935. Oil on canvas, 116 × 81 cm. Collection Giron, Brussels

111 Paul Delvaux, *In Praise of Melancholy,* 1951. Oil on canvas, 152 × 253 cm. Collection Claude Spaak, Choisel

112 Max Ernst, *The Start of the Chestnut Tree,* 1925. Frottage on paper, 26 × 43 cm. Reproduced in the surrealist portfolio *Natural History.* Collection Roland Penrose, London

113 André Breton, *The Comte de Foix Going to Assassinate His Son,* 1929. Collage

114 Jacques Prévert, *Man, Woman and Child,* 1958. Collage

115 Paul Eluard, *Modern Times,* 1937. Collage on paper

116 Jacques Prévert, *The Pleasures of Progress,* 1958

117 E.L.T. Mesens, *Handsight,* 1951. Collage

118 Sculpture by Jean-Pierre Duprey, 1958

119 Max Ernst, *Chimera,* 1935

120 Jean Arp, *Head-moustache, Moustaches and Mask,* 1930. Relief on wood, 85 × 110 cm.

121 Alberto Giacometti, *The Palace at 4 a.m.,* 1932/33. Wood and glass, 63.5 × 72 × 40 cm. The Museum of Modern Art, New York

122 Alberto Giacometti, *The Invisible Object,* 1935. Black bronze, 115 × 32 cm.

123 Man Ray, *Burnt Bridges,* 1935

124 Jean Arp, *Mutilated and Homeless,* 1936

125 Jean Arp, *Bundle from a Shipwreck,* 1921. Wood

126 Max Ernst, *Aeolian Harp,* 1963. Collage, wood, feathers, oil

127 André Breton, *Object-poem,* 1937. Collection Félix Labisse

128 Salvador Dali, *Aphrodisiac Jacket,* 1936

129 Meret Oppenheim, *Lunch in Fur,* 1938

130 Oscar Dominguez, *Peregrinations of G. H.,* 1936. Private collection

131 Wolfgang Paalen, *On the Ladder of Desire,* 1936

Photograph Acknowledgments

Basle: Dietrich Widmer, 120. *Berlin:* Renate Zimmermann, 30. *Brussels:* Paul Bijtebier, 111; Charles Leirens, 41. *Cologne:* Rhein. Bildarchiv, 112. *Dusseldorf:* Walter Klein, 79. *Heidelberg:* Mara Eggert, 49. *London:* Lee Miller, 29. *Mönchengladbach:* Helmut Hahn, 52. *New York:* Oliver Baker, 107; George Platt Lyners, 57; Naomi Savage, 24; James Thrall Soby, 32. *New York and Paris:* Man Ray, 2, 28, 35, 43, 59, 60, 70, 72, 73, 74, 75, 80, 141. *Paris:* Brassaï, 54; Robert Doisneau, 114, 116; Douvenel, 87, 115; Duffort, 1, 93; Foto Cinématique Française, 33, 143, 144; Galerie Maeght, 44, 121, 122, 132, 133; Galerie Louise Leiris, 38, 76, 81; Jacqueline Hyde, 78, 86, 89, 97, 102, 106, 108, 109, 131, 138; René Jacques, 3, 25, 66; Luc Joubert, 94, 95; Jean-Pierre Leloir, 117, 127; Limot, 134; Monde, 83; Photo Savitry, 135; Marion Valentine, 71; Marc Vaux, 103, 119. *Saint-Denis:* Musée Municipal de Saint-Denis, 25, 27. *Villemomble:* Maurice Poplin, 69.

Index

Numbers in italic refer to black and white illustrations; roman numerals refer to colour plates.

André Breton at eighteen months, 1897